Northern Service

Doug Byer

Byer Apr 18/98

Detselig Enterprises Ltd.

Calgary, Alberta, Canada

Northern Service

© 1997 Doug Byer

Canadian Cataloguing in Publication Data

Byer, Doug, 1952-
 Northern service

ISBN 1-55059-149-5

 1. Byer, Doug, 1952- 2. Royal Canadian Mounted Police—Bi-
ography. 3. Police—Northwest Territories—Biography.
4. Northwest Territories—Biography. I. Title.
 HV7911.B93A3 1997 363.2'092
 C97-910410-6

Detselig Enterprises Ltd.
210-1220 Kensington Rd. N.W.
Calgary, Alberta T2N 3P5

 Detselig Enterprises Ltd. appreciates the financial support for
our 1997 publishing program, provided by Canadian Heritage and
the Alberta Foundation for the Arts, a beneficiary of the Lottery
Fund of the Government of Alberta.

Printed in Canada.
ISBN 1-55059-149-5
SAN 115-0324
Cover design by Dean Macdonald.

Table of Contents

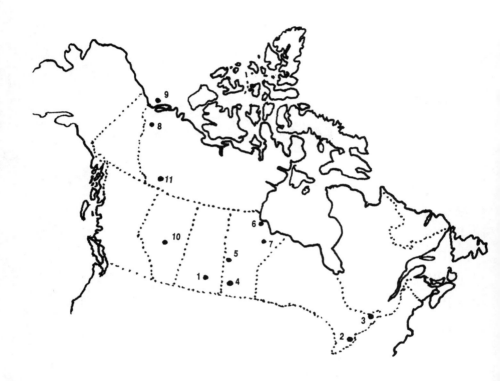

Canada, showing Stan Byer's postings. 1 – Regina, 2 – Hamilton, 3 – Rockcliffe, 4 – Dauphin Subdivision, 5 – The Pas, 6 – Churchill, 7 – Gillam, 8 – Arctic Red River, 9 – at sea with the St. Roch, 10 – Edmonton, 11 – Fort Simpson.

Foreword

Stan Byer

Memories are invaluable. We all have memories; the first are usually of people. And the people of the North are at the top of my list.

Throughout my RCMP service in Canada's North – and my personal interpretation of "North" is north of the 54th parallel in the provinces, and north of the 60th parallel in the NWT – I met many wonderful, gentle and intelligent people. Now, you might wonder why anyone not native to that land might come to settle there. Their reasons were revealed to me as we sat and talked on all those long winter nights, whenever I stopped in to visit those isolated cabins while I was on patrol.

Most were in the North because they loved the solitude and tranquillity of the place, and the honesty of the vast majority of those who were there before them. There were others who migrated to escape family problems, and more were simply after a taste of adventure in Canada's frozen frontier.

My days were spent without the forms of entertainment common today. There was no television and radio broadcasts were extremely rare. Several homes had an old Victrola, and the phonograph platters of the time were very popular. By far the most common method of entertaining ourselves was by playing cards,

with cribbage being at the top of the list. Even school-aged children were adept at the game, and could provide some close competition.

On more moderate evenings, we would step outside and for hours on end watch the Northern Lights dance in the heavens above us. Once, when I was working on the Hudson's Bay Railroad Line in Manitoba, I saw people so engrossed in watching the lights that they forgot to re-board their train before it steamed away without them.

I had not volunteered for Northern Service with some misguided sense that things needed to be "straightened out" and I was the man to do it. Rather, I chose to work for the people and assist them with any problems they might have. More often than not, I found that it was myself who had the "problem" – I often did not understand their ways of thinking and doing things. I was grateful to the many Native elders who were so patient with me in explaining how the "ways of the white man" differed from their own. Many times I came to realize that their ways were superior to what I had been taught while growing up. When it came to matters of law, they were equally patient while I explained how things had to be in certain circumstances.

I may be accused of being lazy, but I found that if you gave the people ample reason to trust you, and showed the elders the respect that their own band members did, the people would pretty much police themselves. In their society, Native elders were held in high esteem, and their word was followed more closely than any "law" which might be imposed by a squad of police who did not have that trust.

Naturally, things were far different then than they are today. I last served with the RCMP in the North more than 40 years ago. That was long before highways were built extending almost to the Beaufort Sea, and huge commercial aircraft filled the skies. It was also at a time when the North was being explored, but not yet being exploited. And the population has shifted as well, from being predominantly Native with an occasional well-meaning interloper such as myself, to one where, by virtue of sheer numbers, the ways of the "outside" have taken over. Those "ways" now include all the kinds of problems those like me were trying to escape more than half a century ago.

Chapter 1

In late 1939, Stan Byer was driving the Regina-Melfort-Saskatoon mainline bus route across Saskatchewan for Arrow Coach Lines. Two years of operating heavy highway transports for the family-owned trucking business based in Saskatoon gave the 22-year-old the skills to secure this plum route ahead of more senior drivers. But, as was the case for many young men at that point in Canada's history, Stan's sense of duty was compelling him to sign up in the armed forces. Great Britain had declared war against the Axis forces in Europe, and Canada, as a member of the British Commonwealth, had soon followed suit.

Stan had completed a few hours of flight training the previous summer, and he was particularly interested in enlisting in the Royal Canadian Air Force. Lineups for the RCAF were blocks long, however, as the United States had yet to declare war against Germany and American pilots, eager for adventure, had trekked their way north to sign up. Stan's name was put on an indeterminate waiting list along with those of several hundred others. And the army had already rejected his application because he had broken his foot the year previous.

In Melfort, Stan met an RCMP constable by the name of Jack Savage who frequented the same lunch counter as he. Over several months' time, the two became friends, and the pair spoke together about many topics, including career choices. Jack understood Stan's frustration at not being able to get into the Air Force, and knew he itched for something other than sitting behind the wheel of a bus.

"Have you ever considered joining the RCMP?" Jack asked one day. "You've got a decent education," he continued, "and experience in a lot of different things. The pay's not great," he shrugged, "but the Force does offer job security. Hell, there's even a pension plan. You might want to think it over."

The last two points were particularly persuasive to Stan. During the "Dirty Thirties," he had seen his father work for a dollar per 12 hour day building roads and bridges in and around Saskatoon. These were not fond memories, and although he made a decent wage with Arrow, the idea of steady employment with a permanent agency was very attractive to him.

Stan had what he believed to be a modicum of experience in police work; on a half-dozen occasions, he had been named acting bailiff when the Waterloo Manufacturing Company in Saskatoon needed to repossess farm machinery which had not been paid for. He always seemed to get the job done without any particular trouble and got along well with people even in those trying circumstances, so the idea of being a full-time peace officer was not completely alien to him.

Anxious to serve his country in some capacity, and having taken Cst. Savage's suggestion to heart, Stan showed up at the RCMP's Depot Division in Regina, made the minimum height restriction of five feet, eight inches with a half inch to spare and wrote his entrance exam. Then he waited.

On a return visit to his home in Saskatoon, Stan was given a piece of mail which had sat unopened for over a month. Within the envelope was word that he had passed his exam, and that his application had been accepted. Elated, he drove the next day to Regina, only to learn that the acceptance contained a caveat; in order to have his application approved, he must first volunteer for the Provost Corps. In the event of continued conflict overseas, RCMP members who were also enlisted with the Provost Corps would be assigned to the Canadian Army to coordinate troop movements, and to carry out mapping and routing duties. Stan understood the transportation business and reasoned that if he would not be able to fly, this just might be an acceptable alternative.

Stan accepted the caveat, was sworn in and was told to report for duty in two weeks. He promptly gave notice at Arrow, but continued to drive his route until he was scheduled to return to Regina for training. On one of his final trips into Melfort, Stan met up with Jack Savage.

"I took your advice," he told him. "And I report next week."

Jack expressed his congratulations, but he had news of his own.

"Hope you don't think badly of me," he said, "but I signed up with the Army. I'll be heading out to training shortly myself."

"But, I thought . . ." Stan began to say.

"Police work will suit you," Jack said. "It did me for a long time. But for now, at least, the Army is something I have to do."

Stan didn't fully appreciate what Jack meant, but something in his friend's voice made him understand that it was important to him, and he returned the congratulations. Jack had one last piece of advice.

"Want to make a good first impression on your training sergeant?" he asked.

"Sure thing," Stan replied, always ready to please. "What do you suggest?"

"Get a haircut," Jack told him, and he wrote out the name and address of a local barbershop. "Tell him you want it tight to the head. He'll know what you mean."

After finishing their lunch, the two exchanged good-byes and went their separate ways. Stan has not seen or heard from Jack since.

On May 20th, 1940, Stan reported to Headquarters Division, Regina. The facility was already crammed to the rafters with 650 men and, despite the fact they had been expecting his arrival, Stan was promptly advised that there was no place for him to bunk. The barracks were full, he was told, and he would have to report at some later date. At the last minute, however, an empty bed was located. A certain constable in "F" Squad, Eugene Hadley, had been transferred to Vancouver to serve aboard the St. Roch, the RCMP's floating detachment and northern post supply vessel, which had been recently refitted to patrol Canada's Arctic waters and ensure sovereignty of the Arctic islands during wartime.

He was in!

Stan reported to the Quartermaster Store and was issued a fatigue jacket and pants, boots, socks, his bed kit and a hat. None of the clothing fit, but of particular annoyance was the hat, which fit snugly at the front and back of his head, but left a half-inch wide gap on either side.

"Don't you have something that'll fit me a little better than this?" he protested, as politely as he could.

The Quartermaster made a quick inspection of the recruit's head shape and concluded that, "It ain't the hat's fault." Stan would attempt to obtain a more suitable hat throughout his training, but not one of the QMs he came across could ever find a match.

Stan returned to the room where "F" Squad was dormed and began to get set up in his new home. This particular group was due to graduate in a very few days, and the men there graciously offered Stan another way to impress the training sergeant – shiny buttons, and the shinier the better. One man went so far as to cut the buttons from Stan's jacket and exchange them for those from his own.

After parade the next morning, Stan was advised that he had been assigned to "K" Squad for training. This caused a little commotion among the other members of "Fatigue Squad," as the group was nicknamed, fresh applicants who had not all been formally assigned to a specific training crew. Many of these men had stayed on at Depot from the same day they had been sworn in, some as recently as a few days earlier, but very few before Stan had signed on. Stan's seniority was effective back to the two weeks prior, even though he had just arrived in person.

Many members of "Fatigue Squad" thus could not understand why this new arrival was moved straight into training ahead of themselves. To this day, many will accept no explanation for the "preferential treatment" afforded him other than the gleaming buttons on his jacket courtesy of his roommates, and the gleaming skin under his cap courtesy of Jack's barber.

Training in 1940 consisted of class time dissecting the Criminal Code, poring over Federal Statutes and studying the history of the Force, identification methodology, forensic science, photography and more, including a seemingly endless number of hours spent before a typewriter. Outside the classroom, time was dedicated to small arms training, fatigue duty, judo and other self-defense techniques, fatigue duty, foot drills on parade grounds, the dreaded stable duty and yet more fatigue duty. (It was fatigue duty which taught recruits the *true* meaning of the initials "RCMP," namely Rub, Clean, Mop and Polish!) Physical fitness was a priority, and the recruits ran miles, lifted weights totaling thousands of pounds each day and were given countless opportunities to perform pushups for their drill instructors.

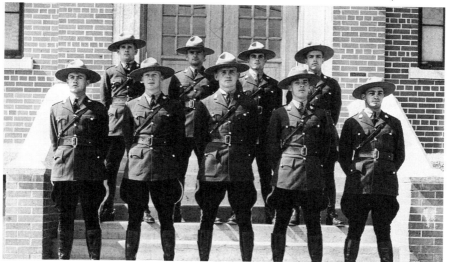

Stan Byer (back, second from left) and the other members of "K" squad.

If drill instructors are stereotyped as being miserable, Stan figures they've earned the honor honestly.

"It was a strict rule," he said, "that you never wore part of your uniform; it was full uniform or full civilian dress, or your fatigues – nothing in between. One poor kid had just arrived and was walking out of the Quartermaster Stores with his kit. He had his arms full, so he decided to wear his hat. One of the drill instructors caught him and really tore a strip off him. The kid had never heard of the rule, but that didn't matter. He was about a foot tall when the DI was finished with him."

Another had little sympathy for artistic license.

"A Hollywood film crew came up to Depot to shoot a scene for a movie. The actor playing the role of the recruit was on the parade grounds one day when an instructor began screaming at him for his 'non-regulation' haircut. The actor tried to explain that he was just playing a role, but that just made it worse. The DI went after the film crew next, demanding how dare they portray the RCMP as such an unkempt group. He wasn't kidding, either, which the crew thought he might be. It just got crazier and crazier. The more they tried to explain, the angrier he got."

Stan was well prepared for both the intellectual and physical challenges presented by the Force. He had completed his grade ten, his education being interrupted by financial demands on his family

rather than by any lack of ability. Besides, there were no restrictions on what he could read on his own time, and Stan was a voracious reader. And all those years of labor on the family farm and with his father's business had steeled his body for anything the RCMP could throw his way in that regard.

It wasn't all sweat, however. One of Stan's fellow recruits, Elgin "Hammy" Hamilton, recalls their group of men as " A crazy bunch of buggers."

"None of us had any money," Hammy told me when I interviewed him. "We had to make our own fun . . . and we did."

One of their squad was quite the practical joker.

"I don't just recall his name, but he was always pulling some sort of stunt. One night after an exam a few of us scraped a few dollars together and went out for a couple of drinks. This fellow had failed his test and was so depressed that he didn't want to come along. Anyway, when we got back, we went into the dorm and there he was, hanging from the rafters in full uniform, stetson and everything. We figured he'd killed himself over failing one exam, and the bunch of us went tearing off to get the night watch. Well, when we got back to the room, he's about busting his gut. He'd gotten some of the other boys to rig it so he looked like he'd committed suicide. He sure got us that time," Hammy added with a laugh.

"We had one guy who would sit on his bed every day, with his legs curled up under him like a snake charmer or something, playing a flute. He wasn't much good, and he drove us crazy with the darn thing. One night we packed as much soap from a bar of Sunlight as we could into that flute of his. Next morning he's all ready to play and it didn't take him long to figure out we'd been at his flute. He just went off into the washroom and ran hot water over it until he could get all the soap out, then he came back, sat on his bed and started playing again. He never said a word to us about it."

The first part of training was three months in duration. Subject to satisfactory performance, a recruit would normally be assigned to the second part of training, also three months long. The majority of "K" Squad was transferred to "N" Division in Rockcliffe, near Ottawa, Ontario, for their second three month stint. Upon arrival in Ottawa, and after a less than comfortable three-day train trip, the squad was told that there was no bunk space ("Where have I heard that before?" Stan thought), and the men were directed to

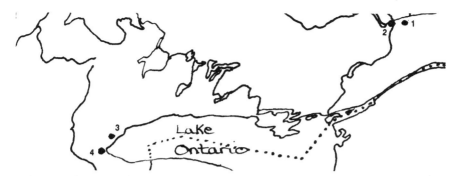

Stan and Hammy's grand tour of southern Ontario. 1 – Rockcliffe, 2 – Ottawa, 3 – Toronto, 4 – Hamilton. The dotted line marks the Canada-U.S. border.

bed down on the gym floor. They had only slept a few hours when Stan and Hammy were told to catch the next train to "O" Division, Toronto, where they were to complete a year's practical field experience. In Toronto, they learned that they had been further assigned to Hamilton Detachment. Yet another train trip! Little did Stan know that all this travel by rail would pale in comparison to that which he would endure just a few years ahead.

At five the following morning, having now spent the better part of a week traveling, the exhausted pair arrived at the Hamilton train station. Hoping beyond hope to have finally found a home, they searched their pockets for a nickel to call for a ride using the station's pay phone. When the phone was answered at the other end of the line, Stan's companion announced, "This is Hamilton." He paused, perhaps expecting the officer to recognize the name. Which he did, in a fashion.

"I know this is Hamilton, smartass!" an angry voice thundered back at him, followed immediately by the sound of the receiver being slammed in his ear. Undaunted, they managed to locate another nickel and placed the call again, this time choosing their words more carefully.

The pair got their ride and reported to the Dominion Public Building where they would be billeted. The building housed, among other tenants, the Post Office. Strangely, though, there was no mailbox outside of the building. Once again, unbelievably, there was no room for either in the dorms. Their night time residence for the next year was the sixth floor janitor's storeroom, at the opposite end from the washroom facilities in a building a full city block long. All that luxury, and a dollar fifty per day (plus meal allowance) to

boot, a far cry from the 150 dollars per month Stan had been earning with Arrow. Stan began to wonder whether "job security and a pension" were worth any of the bother.

The men took their meals at a boarding house a couple of blocks away. Living there were a number of men who were working as mechanics. One of the police officers, Dick Trigg, had purchased a 1931 Chevrolet sedan, and Stan and Hammy were designated as the vehicle's repair team.

"Dick was the one guy we knew who ever seemed to have any money," Hammy smiles. "He made us a deal; he'd buy the car – I think it cost him about a hundred bucks or so – if Stan and I kept it going. Dick could fill a car with gas, but that was about the extent of his mechanical ability. It was real fancy, with wire wheels and all. The car's soft top was a mess though; the roof's wooden header was all rotted out, so Stan and I cut out the frame and took it to a carpenter to build a new one. All these mechanics at the boarding house would just laugh whenever we talked about what we were doing. They figured it was impossible. Whenever we had a few hours, we'd work on that car at a little shop not far from the boarding house. I'll never forget the look on their faces when we finished – 'Holy mackerel, did *you* guys do that work?' they asked – I guess they figured a couple of old farmboys couldn't handle it."

Duty for that year involved observing labor strikes, excise enforcement, which consisted primarily of raids on bootlegging operations, and the registration of enemy aliens. Citizens of foreign countries with whom the Allies were at war were required to report monthly to the RCMP in order to remain within Canada.

Much of their work was done in plainclothes. It would not do, for example, to assemble in uniform prior to a raid, as the element of surprise was often important to the task at hand. Hammy explains, "We weren't to interfere with the strikers, just walk around and listen and observe. But even in civilian clothes, we looked a little suspicious, I guess. I remember one of the guys picked up a placard and started to chant with the strikers so he'd fit in a little better. Well, that day things started to get a bit out of hand. There was an army base about a block away from the yard, and those boys didn't mind getting into it. Our man fit in alright; he looked just like a striker. There was a tussle, but I don't think anybody got hurt too bad."

One particular duty was to escort the Customs agent to the bank each day. There was a seaport at Hamilton, and tariffs and duties were often paid in cash.

"Imagine," Hammy told me, "here we are, raw rookies, just walking down the sidewalk with the Customs agent like we were off to see the sights or something. People bumping into you every step of the way, and the city full of new immigrants with hardly a pot to pee in. We had sidearms, but most of the time they wouldn't let us carry any bullets.

"We'd go down this little alley where the agent had to ring a bell at the back of the bank, then we'd stand there for a few minutes until someone let us in. I know the largest amount I ever saw counted out of that briefcase the agent had was 1 300 000 dollars." Hammy shook his head. "Can you believe it? Over a million dollars every day of the week went into that bank. I don't know why we were never knocked over, thinking about it today. But we never gave it a second thought then. I think I'd want an armored car if I had that detail now."

And there was time for a little fun, too. The Dominion Public Building was blacked out every night. Being situated across from the Royal Connaught Hotel was useful when funds were scarce and the men were bored.

"With no lights on across the street in our building, people in the hotel never were too concerned about drawing their curtains. If there was nothing else we could find to do, sometimes we'd just park ourselves in a dark window and watch the races, you know, couples chasing each other around the room."

One evening Hammy, Stan and Dick and a couple of young ladies rented a 12-foot skiff and went for a little tour of Lake Ontario. The boat had a 12-horsepower engine, and the party rode straight out over the water a fair distance when they suddenly noticed that their boat was starting to pitch.

"You could see the lake was getting rough farther out," Stan recalls. "We turned around and headed back for shore, but we were getting swamped by the waves which had come up. The girls were pretty scared, so Dick and Hammy got into the water and hung on to either side of the boat to keep us from flipping over."

"We got back okay," Hammy added. "But we were sure cold. And we had landed about a half a mile away from the boat launch, so we had a bit of a walk."

Hammy had a cousin, Denzel, stationed at Hamilton at the same time he was there.

"He was a crazy son of a gun. One day I remember he walked downtown and stopped dead in his tracks on the sidewalk, looking almost straight up at the top of a building. After a few minutes, a small crowd had stopped to look too, and it just grew and grew. A little later even a city policeman was standing there trying to see what was going on. Of course, there was nothing *to* see. It was just Denzel's idea of inexpensive entertainment. After a while he got bored with it all, and just kind of wandered off while everyone else stood there scratching their heads."

The men weren't always broke.

"One day we went to a cafe for lunch, and Stan made a call from a pay phone in the hotel lobby. When he hung up, the thing just started pouring money out like a slot machine. That paid for the lunch and a lot more," Hammy laughed.

Their year in Hamilton was relatively uneventful, although there was one particular development of interest to Stan. By early 1941, enlistment into the Canadian Armed Forces had slowed considerably from that experienced only a few months earlier. In response, the federal government declared that the RCMP could no longer accept applicants. So as not to jeopardize the Force's ability to respond to unforeseen future circumstances, the Commissioner of the RCMP countered the government's action by nullifying the agreement to provide men for the Provost Corps. That action effectively closed the door to any chances Stan might have had to gain entry into the Provost Corps, but he was not the type to quit anything he had begun. Resigned to his fate, he carried on with his police training.

Once they had completed their duty in Hamilton, Stan and Hammy were shipped back to Rockcliffe to finalize their formal training. Three more months of reveille at 0530, roll call at 0730, classes until 1630, dinner and then whatever recreation could be crammed in before "lights out" at 2200 hours.

"We were all on the range one day," Stan tells. "We were practising with our revolvers, which was a very strict procedure. At one stage you were to draw your arm tight to your side with the revolver barrel pointing straight up by your cheek, then slowly extend your arm out and fire the round. All of a sudden there's this

The mess at Rockcliffe.

one man rolling around on the ground and clutching at the side of his head."

Hammy picked up the story.

"He was an older guy, said he was a World War One vet, so you'd think he knew a thing or two about handling a gun, but I guess not. He darn near blew his own head off. His hat was still flying through the air when I looked over at him. He had a wound on the side of his face, and I guess he couldn't hear too well for a few days, either."

Aside from a rare weekend pass, the only two opportunities to leave the grounds were a once-monthly church parade, where trainees were permitted to attend religious services in the city, or a dress parade at War Bond sales promotions. Both occasions required red serge, and Stan's sergeant was not pleased with the ill-fitting tunic which had been issued to him. One afternoon Stan was marched to the tailor's facility, where the sergeant demanded that repairs be made immediately. Stan's tunic split at the bottom both front and back, and this was not acceptable.

Taking his tape measure from around his neck, the tailor insisted that the sergeant watch and listen.

"Tell me how," he implored, "can a tunic be made to lay correctly when a man has a 41-inch chest and 44-inch hips, but only a 30-inch waist?" Having little option but to defer to the other's expertise in such matters, the sergeant simply told Stan to try to do something about his "secretary's spread." Stan's defense, rightly or otherwise, was that he had acquired his unusual body shape from sitting for hours on end driving trucks and buses for the past several years, but this made little impression on his superior.

When Stan's graduation day finally arrived in December of 1941, there was virtually none of the pomp and ceremony which accompanies the celebration today. There were neither brass bands nor red serge and parade before senior command. One or two of the sergeants offered their good wishes, but a simple handshake and congratulations among the successful trainees was all that marked the occasion of their induction into the Force.

No lack of ceremony, however, could detract from the immense sense of pride and accomplishment each graduate felt that day. They had made it. Having successfully pushed themselves to the outer boundaries of physical and intellectual endurance, they were now full-fledged participants in Canada's history, constables all (second class) in the Royal Canadian Mounted Police.

Chapter 2

From Rockcliffe, much of the class dispersed far and wide across the country. Hammy stayed in Ottawa at Headquarters Division, and within a few years had volunteered for and was accepted into the Musical Ride, perhaps the most recognizable aspect of the Force throughout the world, both then and today. Cst. Byer was assigned to "D" Division in Winnipeg, Manitoba, where he stashed his gear and returned home to Saskatoon for his first leave in a year and a half. Upon his return to Winnipeg three weeks later, he was immediately sent on to Dauphin Subdivision, located in the province's northwest.

Dauphin was a busy post, having two RCAF training stations nearby. The transient population kept the police busy breaking up disputes at the local taverns. Drinking ranked highly among a very limited number of opportunities for entertainment in the isolated communities of the North, but it was not a vice reserved for airmen alone, by any means.

As the resident novice constable, Stan often drew the more mundane duties. On one occasion he was driving a magistrate and the Crown prosecutor to the town of Roblin to hear cases. On the return leg, he heard a popping sound come from the back of the car, and in his rear view mirror he saw the two men each drinking a fresh bottle of beer. Stan pulled over to the side of the road, full of innocent amazement at what he saw.

"What's the problem, Constable?" the magistrate inquired.

"Excuse me sir," Stan managed nervously, "but did you not just issue convictions to several people for similar offenses?"

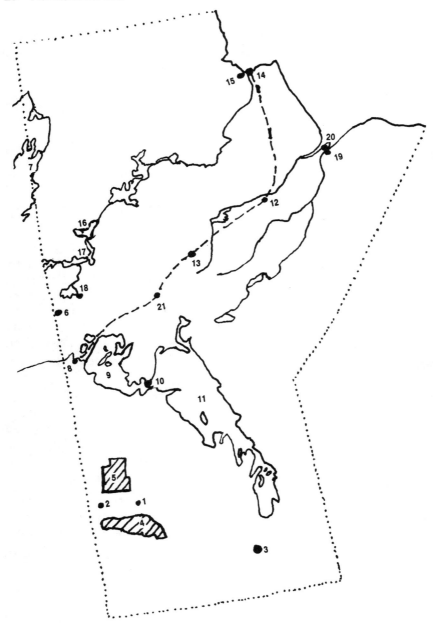

Manitoba. 1 – Dauphin, 2 – Roblin, 3 – Winnipeg, 4 – Riding Mountain, 5 – Duck Mountain Game Preserve, 6 – Flin Flon, 7 – Reindeer Lake, 8 – The Pas, 9 – Cedar Lake, 10 – Grand Rapids, 11 – Lake Winnipeg, 12 – Gillam, 13 – Pikwitonei, 15 – Fort Prince of Wales, 16 – Granville Lake, 17 – Highrock Lake, 18 – Sherridon, near Kississing River and Lake, 19 – York Factory, 20 – Port Nelson at the head of the Nelson River, 21 – Wabowden.

Right was right apparently, as neither of the Crown's representatives offered any defense, and both put their beer away, saving it until they were back in Dauphin.

One event which happened early in Stan's stay had the potential to be something more than "routine." Twenty miles out of Dauphin, in the Riding Mountains, was a Prisoner of War camp, and the RCMP received a message to send a squad of men in bush dress to assist in rounding up a number of escaped prisoners. The excitement was just beginning to mount, however, when a cancellation order was received. As it turned out, the German army was not too well prepared to cope with the winter conditions in and around Dauphin, and the escapees had lit a giant fire, which the Army had spotted almost immediately.

Their reason for lighting the fire was not only the most obvious one, that is, to keep themselves from freezing. Rather, their primary intent was indeed to signal the Canadians, as the POWs were hopelessly lost and in danger of starving to death. Incarceration in a warm facility and a healthful diet was a far preferable alternative to that which they now faced.

With the understanding that there was no substitute for experience, Stan readily accepted assignments with more senior members in order to observe field techniques. Stan noticed that the man who was achieving the most enviable results, Cst. Charlie Klapecke, was often on his way home by five o'clock, and rarely worked overtime. While along on one investigation with Charlie, Stan paid close attention as he interrogated a farmer with respect to a series of thefts. Charlie asked questions, then stood patiently by while the farmer discussed the situation in the Ukrainian language with his associates, family members and hired help. The reply, accompanied by an apologetic shrug of the shoulders, was that the man had no knowledge of the thefts. Charlie thanked him for his time and drove back to the detachment with Stan in tow, apparently no closer to a resolution. A few days later, he asked Stan to accompany him on a return visit to the farmer's home. Once there, he told the suspect that he had spoken with witnesses, then he explained just how the thefts were committed and precisely who all were involved. The farmer reluctantly admitted his own guilt, confirmed the identity of his accomplices and was then escorted back to town where formal charges were laid.

Shortly thereafter, a second investigation was conducted in a similar manner, and with the same results. Stan asked Klapecke how and where he had managed to find the witnesses.

"Can you keep a secret?" Charlie smiled.

"I suppose so," Stan said. "What's going on?"

"There aren't any witnesses," Charlie admitted with a self-satisfied grin.

Charlie Klapecke, who spoke English with the intonation and inflection of any other Prairie boy, was in fact a first generation Polish/Canadian, and he had learned seven languages while at home as a child. Among these languages was Ukrainian, and he had simply feigned his inability to understand the suspects as they unwittingly dug themselves a hole by confirming the details of the crime while he listened. By waiting two or three days before confronting the suspect with news of a witness, Charlie never gave away the fact that he could eavesdrop on conversations in a "foreign" language.

"They even threw in a few pretty unflattering names for the two of us," Cst. Klapecke added with a laugh.

Meanwhile, back in Winnipeg, the Manitoba Game Branch had received word of elk poaching in the Duck Mountain Game Preserve near Ethelbert, which was under the jurisdiction of Dauphin Subdivision. Judging from the number of animals being taken, the local game warden was clearly in over his head in attempting to stem the flow of illegal meat. Winnipeg sent a deputy warden north to enlist the assistance of the RCMP in putting an end to the problem. Stan was selected for the investigation.

Cst. Byer arrived at Ethelbert with the deputy, and together they solicited the resident game warden's help in determining precisely which specific areas within the preserve were being exploited most often, and which were most likely to produce arrests. Together they compiled a map of sections to watch, and the two investigators were given keys to the game warden's own cabin, which they used as a command post, at Singoosh Lake. After agreeing upon a schedule, the two men set out and for a period of two weeks they patrolled those areas thought most apt to be fruitful, often sitting for many frigid hours right among the herds, which apparently had little fear of men. Each night the pair returned to the cabin with nothing to show for their efforts. Maps were reviewed, their schedule of patrols reaffirmed, and with renewed resolve they would set

out once more the next day, only to be met with further frustration. While the animals were plentiful, there was no sign of anyone illegally hunting them. The pair decided that a new strategy was in order.

Cst. Byer and the Game Branch officer wended their way across frozen roads toward the western perimeter of the game preserve and sought out the game warden whose responsibility included that section. They recounted their attempts to him.

"We haven't seen a soul," Stan suggested. "And if that much game is really being poached, we shouldn't be empty-handed with all the time we've put in."

They asked for further guidance in resolving the matter. The warden was strangely vague in his answers, at first offering that he knew little or nothing of the situation. With some persistence, Cst. Byer and the deputy convinced him to volunteer that the solution might well lie closer to Ethelbert than within the preserve itself. He suggested that they speak with the townspeople to obtain more information.

Feeling they were on the right track at last, Cst. Byer and the deputy warden did just that. While the interviews produced only hearsay evidence, there was a unifying element in what they were being told. Among those with whom they spoke, it was widely believed that it was the game warden himself who was behind the poaching at Duck Mountain. This was one possibility that definitely made sense.

Armed with these accusations, they confronted the game warden. The man did not hesitate for a moment, readily conceding that he had not only permitted the poaching, but also that he had often permitted his own cabin to be used as a base camp by the poachers. The reason Cst. Byer and his superior had been unsuccessful in catching anyone in the act was also revealed; having the pair's schedule in hand, the game warden had simply warned his clientele that the police were watching the preserve, and had directed the poachers to areas other than those being patrolled on any given day.

Charges were never brought by the Game Branch against the resident warden, even though he had confessed to the wrongdoing. While dismissal might have been the minimum discipline expected, the man was merely transferred to a different game preserve further to the east. Perhaps political influence was alive

and well, even in 1942, even in frozen Manitoba. Cst. Byer had to satisfy himself with the fact that at least the poaching at Duck Mountain had been stopped through his assistance to the deputy warden from Winnipeg.

This had been but the first of many assignments to Game Branch that Cst. Byer would receive. The Manitoba government had for some time been developing the Summerberry Rehabilitation Project, the goal of which was to reestablish muskrat and beaver populations in order to provide a living for the people residing there, many of whom had seen their annual take from trapping fall to below 100 dollars. The project was overseen by Tom Lamb, an entrepreneur who had begun his own muskrat ranch on land leased northeast of Summerberry, although on a much smaller scale than the 130 000 acre project the government had in mind. The results of the provincially-funded damming program were so successful that much illicit trapping and hunting activity had been attracted to the area, in addition to the legitimate trapping which the project was intended to support.

Tom Lamb not only owned and operated a muskrat ranch, he also ran a small shipping company. His fleet included a tug and barge, which were used to ferry freight into this part of the country, and he flew his own aircraft on charter trips. Tom and his family had a reputation for possessing an odd sense of humor. In Toronto to purchase a new aircraft, Tom arrived at the factory wearing a set of stained and torn coveralls and several days growth of beard. He presented an oil-smudged cheque to the salesman and stated that he wished to take possession of his plane then and there. The salesman hurried to the back of his office, and returned to say that it would take a few hours to have the cheque approved. It was exactly the response Tom had anticipated.

He asked for his note back, insisting, "If you think my cheque is no good, you're just going to have to take cash." He then produced the entire 50 000 dollar plus sale price in neatly folded bills, all the while enjoying the salesman's obvious embarrassment.

Tom was a lifelong resident of northern Manitoba, born to an Anglican clergyman and his wife in 1899. Eventually he purchased the trading company which his father had started, and created even more ventures on his own initiative. Fluency in the Cree language gave him no small advantage in business, and over time he built an extensive transportation company, even building the winter roads required on which to run his trucks and haul fish. His

companies and the ultimately successful Summerberry project provided jobs and income for many people in his native region.

One spring afternoon in Dauphin, Stan noticed through the window another constable, Percy McLaughlin, struggling in an apparent attempt to educate himself in the proper use of snow-shoes. Cst. McLaughlin had just received word that he was to proceed to the Summerberry Rehabilitation Project. The duty would involve lengthy winter patrols, and he was trying to become accustomed with the tools of the trade before departing.

"Need some help, Percy?" Stan asked. He was happy to take the opportunity to get some fresh air, and proceeded to give the hapless novice some expert instruction.

The Officer Commanding, Superintendent Fowell, observed their antics and called Cst. Byer in to find out from where he had obtained his experience. Stan explained that while he drove trucks for his father spring through fall, operations would shut down for the winter months when the roads were impassable. To earn a living during these times, he had trekked north to Flin Flon, which straddled the Saskatchewan-Manitoba border and which was home to his sister Ethel and her husband John Einarson, a trapper and guide. Over two separate four-month periods during 1936-37 and 1937-38, Stan had been indoctrinated into the world of snow-shoeing and dog team mastery while working commercial fishing concerns operated by his brother-in-law. The work involved setting nets on Beaver Lake adjacent to Flin Flon and, in the winter of 1937-38, fishing Reindeer Lake, yet another 150 miles further north. Their nets and the subsequent catch were ferried to and from the base camp by dog team.

That was all Supt. Fowell had to hear.

"You've just volunteered for Rat Patrol, young man," he advised, as the duty of chasing down muskrat poachers had come to be called. In short order, McLaughlin was given other duties and Stan boarded a train to the RCMP detachment in The Pas, 250 miles north of Dauphin. Stan was introduced to the Summerberry reserve by Les Ferguson, a constable with three years seniority and a full year's Rat Patrol experience. Les was six feet, two inches tall, and a former amateur boxer who once ranked among the top three in the country. After a few patrols with Les as a guide, Stan felt that he was ready to tackle one alone.

It was during this first solo outing on Rat Patrol that Cst. Byer had his initial brush with danger as a member of the Force. The danger was provided by Mother Nature, rather than by man, however. Cst. Byer and his dog team were returning to Cedar Lake Cabin, an overnight station constructed by the Manitoba Wildlife Department half way between Cedar Lake and The Pas. Heading north along a nameless muskeg creek, he and his team approached a fork in the frozen pathway. The path to the west provided a much shorter route to Cedar Cabin, and they had used this branch on their journey south. The dogs made for the left branch out of habit. Stan, however, saw black ice just beyond the fork, which signaled that it had been undercut by the creek's current.

"Whoa, boys," Stan called, with no reaction from the team. The sled dogs were not yet used to either his commands or his mannerisms. Accordingly, they ignored his demands and gestures to turn right. The policeman chased the team down, grabbing at their harness just as the rotten ice gave way beneath his feet, plunging him waist deep into the numbing cold.

As fortune would have it, the dogs' owner was less than gentle in his treatment of the team. Fearing that their new master was of the same disposition, they tried to escape his anticipated wrath by fleeing away from the creek as quickly as they could run. Hanging on to the harness for dear life, Cst. Byer was dragged to safety by the team, whether purposefully or otherwise. After making a roaring bonfire by which to dry his clothing and warm himself, Stan was joined by a half dozen unsure sled dogs seeking rest and rations.

Instead of a beating, the dogs were treated to lavish praise and good-natured roughhousing. Responding to this much preferable handling, the team afforded their temporary master their very best behavior for the balance of the journey back to Cedar Cabin. The dogs had the respect of the man, as well.

Later that same year, Stan and Cst. Ferguson were preparing for a canoe trip to Grand Rapids at the mouth of the Saskatchewan River on Lake Winnipeg. While they made preparations to cross Cedar Lake, the winds began to pick up, and the pair was unsure of the best way to navigate their way south. One of the local residents was on a mail run in his own canoe, and offered the services of his young son as guide.

"The boy's made this same trip lots of times," he explained. "He won't get you lost."

What none of them realized was that, quite typically of most little boys, while he had made the trip with his father, he had never really been paying much attention. This was not, however, something the lad was about to admit. The boy's father headed on his own way and, once the Mounties were finally ready, they asked the youngster for directions. Without hesitating, the boy pointed straight across the lake to the opposite shore.

It was not long before the two policemen began to wonder about the route. Their canoe was tossed about in the waves like a cork in the ocean. They inquired more than once whether the youngster was sure of the way, but he would simply smile and point in the original direction. At length they arrived on the south shore, wet but alive.

A day later they met up with the boy's father, and Stan thanked him for his help, commenting on the rough ride. This prompted the water-going mailman to ask by which route his son had guided them. When Stan told him they had come straight across the lake, the Native looked at him like he was crazy.

"You can't go that way," he insisted. "Impossible. There's rocks," he added as testimony to the proof of his comment.

On the return trip, in fine weather and calm waters, Constables Byer and Ferguson decided to retrace the route in an attempt to

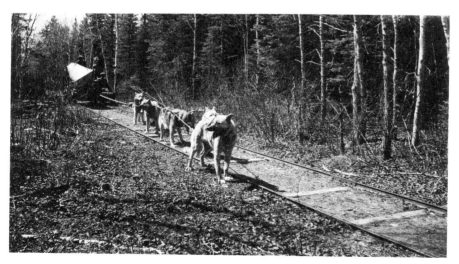

Portage at Grand Rapids. Here, a set of tracks was installed and dog teams hauled men and equipment to a safe area along the river where the boats could be used once again.

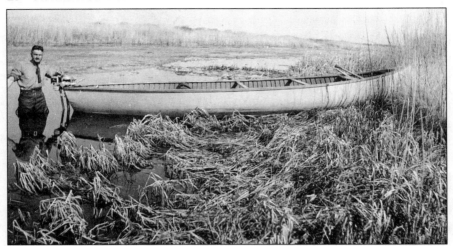

Stan and the usual mode of summer transport, a 17 foot canoe with outboard motor.

determine just what the impossible part was. Halfway across Cedar Lake they found out. There was indeed a reef-like series of rocky outcroppings jutting up from the lake bottom and extending about six inches above the water's surface. The reef extended for a considerable distance in each direction opposite their intended line of travel, and it was quite a chore to hoist their canoe up and over with little foothold. It was apparent that the wave action had not only concealed the danger from them on their first crossing, but it was also responsible for lifting their canoe right over top of the barrier and keeping their craft from being torn apart by it. It had been remarkably good fortune that they ever completed the first part of their recent trip.

There were other hazards to be reckoned with when traveling waterways in the wilds of Manitoba. On one trip Stan was running late, and his guide was using his three cell flashlight to keep a watch on the shoreline. At one point the light's beam reflected off the eyes of several animals. Believing these to be dogs tied up on the beach, the guide signaled Stan to head toward shore. The pair had been looking for a camp of people in this area, and they thought that they had found it at long last. As Stan paddled the canoe closer in, he was startled by sudden screams from the front of the boat. He looked up to see the guide waving his arms frantically.

"Turn around!" the guide yelled. "Get us the hell out of here! And fast!"

As Stan pivoted the craft in a frenzied reversal of direction, it became all too obvious what they had stumbled into. The "dogs" were in fact four bull moose – and it was rutting season! The animals had no patience with any outside intruders, and were charging through the water at their 17 foot long canoe. Both men dug their paddles deeply into the water, straining with all their might. Stan reached for the outboard motor's starter rope and pulled, praying it would kick on the first tug. It did, and the damage was restricted to a royal soaking as the moose angrily thrashed alongside their boat.

Out of harm's way, the tension subsided.

"I thought you might have to get married to that big bull," Stan's guide teased.

"More your type," Stan retorted, getting a paddleful of water in the face for the comment.

Both men agreed that the episode had been too close a call. But then Lady Luck had shined on Cst. Byer for most of his life, and she had not let him down on this occasion, either.

The Manitoba government was devoting considerable resources to the management of wildlife in 1942, and Stan's patrols made him familiar with a great deal of the thousands of square miles of territory which lay in the heart of the province. For the most part, he was being utilized as the "extra man," filling temporary man-power shortages in The Pas, Gillam or Flin Flon. The Hudson's Bay Railroad ran regular service through this part of Manitoba, and although the accommodations were not always first class, this was the fastest means of shuttling between The Pas and Gillam, 325 miles north and east.

Stan and Cpl. Alva Edison "Dinty" Moore were accompanying one another on a train trip from Gillam. At a stop in Pikwitonei, they were approached by one of the two railway repairmen stationed there.

"You boys hear of a deserter from the army being around here somewheres?" he inquired.

They confirmed that they had, and the section man told Moore that he was fairly sure that he had seen the AWOL soldier board the train just moments before. Stan and Dinty walked through the train and found the man buying confectioneries. He reluctantly admitted his identity, and was told to stay on the train for a free trip into The Pas to face charges.

Back on the station platform, meanwhile, the pair of section men were embroiled in a bitter argument. After intervening, Stan found out that neither liked each other much at the best of times, but what had caused this most recent fracas was the fact that the deserter was the brother of the second railway man. Cst. Byer never did find out what, if anything, was done in retaliation for this particularly nasty escalation in their already unfriendly relationship.

Often on these train rides, the constable had to make himself comfortable in the baggage car or in one of the freight cars. It was during such travels that one of Stan's God-given talents occasionally contributed to the detection of smuggled pelts. Just why he had been blessed with his particular gift, Stan did not know, but there was no doubt that when in the presence of beaver skins, he could sniff them out as well as any bloodhound.

On one occasion, while he was preparing for a night's rest in a storage shed beside a freight stop, Stan's ever-vigilant proboscis picked up the unmistakable scent of beaver hides. When the train arrived the next morning, he started up a casual conversation with the freight master.

"Got any shipments of beaver this trip?" he asked.

The freight master double-checked his manifest.

"Nope," he replied. "Not this time around."

Stan then asked to whom a particular crate was consigned and, when given the reply, he made a call from the station's telephone to the Game Branch in The Pas. Based on previous experience with Stan, the Game Branch did not question his accurate (if unorthodox) method of collecting evidence, and they met the owner of the illicit pelts as he attempted to collect the shipment. On opening the box, it was apparent that Stan's suspicion had been "right on the nose," and the smuggler was arrested.

In July of 1942, Stan's duty changed temporarily when he was ordered via wireless message, relayed to the RCMP by the Hudson's Bay Railroad agent, to report to Churchill on an urgent basis.

Along with five other constables from around the province, Stan arrived in Churchill to join the permanent detachment of two men already there. Why eight men were required to police a population outnumbered a hundred to one by polar bears was a mystery to all. Even the sergeant in charge, a man by the name of Greaves, had not been made privy to any details. Without much to do in the way

of police work, the men played a lot of cards, and fell into the habit of sleeping in in the morning.

On one such morning, the reason for their presence was made much more obvious. Stan was awoken from a sound sleep by one of the other men shouting, "Where the hell did all the tents come from?"

At first no one else in the building paid the constable much mind.

"I'm not kidding, you guys," he repeated. "There's a million bloody tents out there."

One by one they made their way to the detachment's window to see for themselves. Overnight, 7000 US Army personnel arrived, made up of troops, the Army Corps of Engineers, Headquarters Battalion and Port Battalion. They had arrived by train and erected a massive tent city without anyone even knowing they were coming.

What the Americans had in mind was to take strategic advantage of Churchill's proximity to the Hudson Bay Straits, and to utilize the location as a huge marshaling area for equipment to be forwarded to the European theatre via Hudson Bay, the Arctic Ocean and finally, the Atlantic. As well, Churchill would serve as

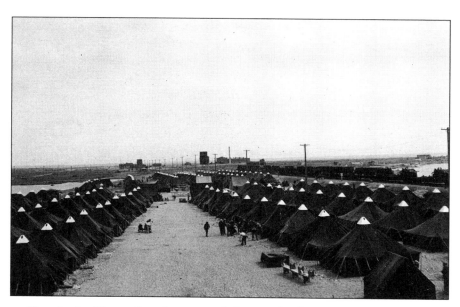

Hundreds of tons of equipment and thousands of men were marshalled at Churchill by the U.S. Army early in W.W. II.

a supply depot during the planned construction of airports at Southampton Island and Frobisher in the Arctic.

Sergeant Greaves got dressed and wandered down to the camp to introduce himself to the American Commanding Officer, Colonel Noble, who in turn advised his host of their purpose, and advised him further that over the next three days trainload after trainload would be arriving, comprised of even more men and equipment for the job at hand.

"I guess it's just a good thing this was a friendly invasion," Greaves told him, as he looked out upon the massive encampment which spread clear across the Churchill flats.

Thus, the mystery of their mission in Churchill had been solved. As confirmation, approximately two weeks *after* the first arrival of the Americans, the detachment received written orders to expect them ". . . at any time." Meanwhile, matters were well in hand, and Cst. Byer was ordered to report back to The Pas for a two-week period. The orders were specific – he was to wear only his "bush" clothes.

Once more Game Branch had been alerted to illegal trapping. This time it was beaver pelts being taken from the area of Granville Lake. Cst. Byer and George Richards, a Native guide, boarded a Game Branch Fairchild 82 single engine float plane and flew north to Highrock Lake, which lay just south of Granville. Aboard the aircraft were provisions for an extended patrol, and tied securely under the plane's belly was their mode of transportation, a freighter canoe.

Stan was to masquerade as a prospector on the journey down the Churchill, and his orders were to take no action, but only to observe and report on the route or routes the poachers were using to escape detection. Coded messages were decided upon which would provide Game Branch with the information they required to put an end to the smuggling. As well, arrangements were made that Cst. Byer would somehow get a letter to the manager of the Royal Bank in The Pas. The manager, in turn, had offered to quietly forward the letter to the Game Branch. The intricate planning filled the case with intrigue.

After landing, George and Stan made their way west across the lake, but after nearly a week, they had yet to catch sight of the smugglers. George, who knew the water system well, believed their quarry could have been exiting the northern rivers through

one particular area named Granville Falls. From that point there were many routes south. The two agreed and made camp in the deep brush adjacent to Granville Falls, waiting patiently for the trappers to show themselves.

Within a few days, a group of men arrived. George spotted them first.

"There they are," he whispered, pointing up the shoreline.

From their vantage point, Cst. Byer and his guide could see that the group had several hundred pelts. They followed the group from a safe distance, eastward, back across Granville Lake. Then they tailed them further until it became apparent that the route they had chosen would take them through Herb Lake, a railway siding from which the men and their booty went on to The Pas by train. Stan and George had the information they were after, and headed south towards Sheridan on the Kississing River. En route was a bay where float planes would deliver supplies to, among others, the very poachers Stan and George had followed until recently. Stan had composed the coded letter, and he handed it to an unwitting pilot and continued on to Sheridan with George.

It was a miserable final leg to the patrol. Cold rain saturated their clothing, and the pair paddled day and night to get back to warm beds and a hot meal. Arriving in Sheridan on August 19th, they stowed their canoe and gear and made their way to the hotel, where they would spend the night before catching the train into The Pas the next morning. The manager built a roaring fire in the lobby's stone fireplace and while resting, Stan and his aide took the opportunity to damn the conditions they had just gone through, complaining for the benefit of anyone willing to listen. In the meantime, the hotel manager turned on the radio, hoping to hear news of the war. While reception was normally poor, on this evening the Canadian Broadcasting Corporation's signal was crystal clear. The news was not good; some 5000 Canadian troops had, that same day, taken part in a raid on Dieppe on the northern coast of France. Nearly a 1000 had died in the ill-fated landing, and some 3000 more had either been wounded or captured by the enemy.

If ever men could experience true contrition, Stan and George did that night. Their hardship dimmed to nothingness in comparison to that undergone by so many others, in a land so far from home. There was little joy to be had in the knowledge that the fur smugglers had been arrested in The Pas.

Chapter 3

That assignment with Game Branch completed, Stan returned once more to Churchill. As fall turned to winter, their American guests were becoming less and less comfortable. By November, their tent city woefully inadequate to cope with the climate, most of the contingent returned to the United States. With virtually no one left to police, Cst. Byer was ordered back to Gillam. Here, among other pursuits, he courted a young woman by the name of Jean Rafter, whose father worked for the Hudson's Bay Railroad as road master. It was a fateful meeting, in the most positive sense, as these two would come to know in future years.

Besides Game Branch duty, police work in Gillam included patrols of the Hudson's Bay Railroad by gas car, and acting as Indian Agent on behalf of the

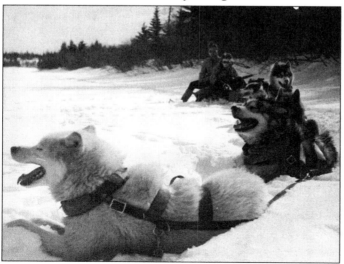

Stan and Jean on a Gillam-style sleigh ride.

federal government. The RCMP was responsible for collecting vital statistics, primarily the registration of births and deaths, among the Native population who resided in the region.

In February of 1943, Cst. Byer was to make a patrol to York Factory and south for the purposes of advising Treaty Indians of a three-month amnesty program announced by the government, which related to the disposition of beaver pelts taken out of season. At the time, the Native population was free to hunt or trap at will, but pelts taken out of season were to be used solely for making clothing. Under the government plan, any accumulated pelts could be surrendered and the owner would receive one half of the proceeds obtained by auction in Winnipeg with no further penalty applied.

On the return trip, some of Stan's dog team inadvertently injured their feet in water overflowing the Nelson River ice in 40 below zero temperatures. Resting the injured animals in York Factory, Stan decided to take the healthy dogs and tour Port Nelson, the original site for the railway terminus eventually completed at Churchill. Some 20 years earlier, the site was changed when it was determined that the bay at Port Nelson was solid rock and could not be dredged. The dredge ship, however, had already arrived from England. A vicious storm had engulfed the vessel and deposited its broken spine atop the bridge trestles spanning the bay. It was these remnants which the restless constable wished to see firsthand.

Accompanied by the 16-year-old son of the Hudson's Bay store manager, Stan set out. Crossing the miles wide channel into Port Nelson, the entourage was hit by severe weather. Having to pull the dog team by hand into the biting north winds, the two finally found shelter in the old RCMP post, which had been abandoned in the late 1920s. They scouted the post, finding ample supplies.

"Look here," Stan encouraged his companion, "there are stores of pemmican, canned condensed milk and hardtack bread. Hell, we can stay here 'til spring if we have to."

Fearing the meat had been spoiled, Stan decided to utilize the dogs as royal tasters. They survived quite handily, and the policeman and his companion ate well for the following two days, between tours of the deserted township.

One of the more spectacular sights in the North is the Aurora Borealis, more commonly referred to as Northern Lights. Multi-

The long-abandoned RCMP detachment building at Port Nelson, where Cst. Byer took shelter for two days and nights when severe weather interrupted a sight-seeing tour of the town site.

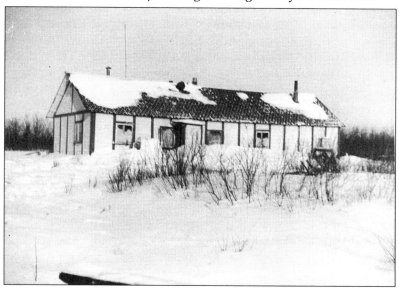

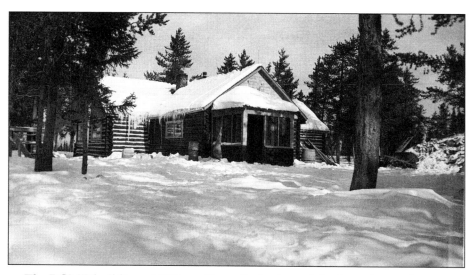

The RCMP building at Gillam. From the back yard during winter, the Northern Lights could be witnessed in their most awe-inspiring glory.

hued ribbons of light seem to dance in the night skies at select intervals. Many choice vantage points exist in the North from which to observe this phenomenon, but Stan recalls none more fondly than the back yard of the police detachment in Gillam. Nestled in the middle of a stand of tall conifers, the post was at the very centre of a 100 yard wide, pitch black chimney that seemed to accentuate the already brilliant colors which Nature put on display for all to see and enjoy. Anyone who sat in the police yard on those evenings when the lights were unusually active might swear that they could actually *hear* them as they seemed to weave amongst the trees. Many were mesmerized by these lights in the same way that watching the flames of a campfire can capture one's attention for several minutes at a time. This is a fact to which a number of US servicemen in northern Manitoba at the time can attest.

Many of these foreign visitors had never even heard of the Northern Lights, let alone seen them in all their glory. Stan was aboard a train full of American soldiers which had stopped at Wabowden on its way to Churchill. While the train took on a fresh tank of water and had its coal supply topped up, the troops took a moment to stretch their legs on the station platform. Those to the rear of the train had an unobstructed view of the lights.

There were several calls to their fellows.

"Hey, you guys! You ain't gonna believe what's goin' on up in the sky!" one yelled excitedly. A number of men exited the train and ran to see for themselves.

This was Stan's stop, so he joined the other men on the platform. There was much ooh'ing and ah'ing as the soldiers watched the display, while the policeman explained what it was they were witnessing. All at once, the station master came running out of the building, yelling. The train was an eighth of a mile down the track, and none of them had even noticed it leaving. As the light at the end of the caboose became ever smaller, the Americans resigned themselves to a night's wait for the next train. Cst. Byer never heard whether they faced charges for being AWOL – Awed While Observing the Lights.

Stan was occasionally required to escort prisoners from the more northern posts back to Dauphin Subdivision. When these trips coincided with weekends, he was usually put on call while awaiting the next train out. On one such Sunday, he received an urgent message that an RCAF trainer had crashed nearby. The exact

location had been relayed to him, and he raced to the scene in the police patrol car. As he passed the field where the wreckage was supposed to be, all he could see was a small stand of brush no larger than a city lot. At the edge of the field there was a farmhouse where Cst. Byer stopped and banged on the door.

"Anyone here see or hear a plane come down?" he asked the man who answered the pounding.

"Over there," the farmer said, pointing back to the clump of brush from which, Stan now noticed, what looked like a light grey mist was still rising. He raced to the scene, and on closer inspection, the constable could see that the aircraft had buried itself on impact.

His duty was to keep unauthorized civilians away from the site until military personnel could have an opportunity to investigate and hopefully recover any survivors, but one look at what remained told Stan that there was virtually no chance of anyone getting out alive. Within minutes, the Air Force rescue team arrived, and it was not long before the obvious was confirmed. The ambulance crew was comprised of Women's Air Corps members, and their cool efficiency demonstrated to Stan that even the most horrifying duty can become almost commonplace with experience.

What had killed the pair of unfortunate pilots was not the crash itself; rather, they died as a result of a mid-air collision. None of the three trainers flying that day was equipped with a radio, thus the lead pilot had to signal changes in formation by waggling his wing tips. Flying in an inverted "V" formation, the number one aircraft signaled a shift to what is called "line astern." To accomplish this maneuver, the aircraft to the right – aircraft number two – should have fallen into place directly behind the lead plane, which it did. The trainer on the left – aircraft number three – should have taken the tail position, and all three would then be in a straight line. The fatal error made was that the pilot on the left misinterpreted the signal, apparently believing that the lead pilot had called for an "echelon left" formation. To achieve that arrangement, aircraft two would have had to fall into place behind and further left of aircraft three, while three retained its position relative to number one. The formation as seen from above would resemble a diagonal line " / ."

Realizing that number three had not altered its position, number one repeated the signal to form a "line astern." This time three's pilot correctly interpreted the message but, believing his wing man was to his left and rear, he simply shifted right to fall in line behind

the lead plane. At that point his plane collided with the number two aircraft, which he obviously had not seen. The steel propellers tore through the thin canvas layer above the flight deck of the second plane, decapitating the two men inside and killing them instantly.

Falling from a height of 4000 feet above ground level, much of the airframe had become embedded in the field, and no part of the plane was recognizable. The bodies of the men inside were similarly disfigured. Stan watched in stony silence as the WACs calmly placed the remains into rubber body bags, taking inventory as they went about their grisly chore to ensure that the correct number of parts and appendages were recovered to assemble a complete human being. As they went about their business, one of the women bent over to inspect something on the ground. She lifted a one foot square flap of skin, only then realizing that it was the death mask of one of the two pilots, as devoid of any underlying tissue as would be the case if an expert taxidermist had prepared the macabre sample. From his position, Stan could clearly see the eyebrows and mustache, which less than an hour before had belonged to a living person. It was a scene he would never forget, as much as he wanted to.

Among the officials beginning to gather at the site, Cst. Byer noticed the Subdivision's Officer Commanding and Sergeant. Word had been relayed that the command pilot of the ill-fated trainer was the son of Assistant Commissioner Caulkin, and the two had been requested to attend the crash scene and report back to the officer. At best, all they could offer was that the man's son had not suffered.

The bodies were removed by ambulance, and the twisted wreckage was hauled away on the back of a flatbed truck. When the cleanup was completed, almost no sign remained of the carnage which had taken place on this Lord's Day in remote Manitoba.

Death would not be a stranger to Stan during his early years in the Force. The proximity of The Pas to Flin Flon provided Cst. Byer the opportunity to visit with his sister and her family whenever he could arrange some time off. Ethel and John had a young son, and Stan was very fond of his nephew. Tragically, Jimmy drowned at the age of two and a half years. Ethel gave birth to another son, Danny, shortly afterwards, and Stan had seen the little boy only once when he had a horrifying dream.

During the course of an evening layover at Cedar Cabin, Stan awoke three times. On each occasion he was bathed in sweat, and tears were streaming down his face. What had awakened him was the same numbing nightmare, that Danny had died. Unable to sleep for more than a few minutes without having the vision recur, the constable simply gave up trying and sat awake for the rest of that night.

In the morning, his guide asked what had happened to make Stan cry out in his sleep. Stan had not been aware that he had disturbed his companion.

"Sorry if I woke you," he apologized, and told the other man of the dream. The elderly Native fell silent. After a few moments, the guide suggested softly that Stan should contact his sister at his first opportunity.

"This means something, this dream," he whispered. "The boy's spirit calls to you."

When Stan called Ethel, she confirmed his worst fears. Danny had been taken from her at less than one year of age, struck down by spinal meningitis. The doctors had been helpless to save the infant, or even to relieve his pain as the disease twisted his body into contorted shapes. Stan related his dream to Ethel, who told him that the baby had died the same night as Stan had dreamed of it. She went on to say that she too had had a dream that night after taking Danny to the hospital.

"I was walking with Danny," she began tearfully. "We passed beside a small park, and Jimmy came out from behind a bush. He held out his little hand to his brother, and he had never even known him. Jimmy invited him to come and play with him in a place where there was no pain. And when I woke up the next morning, I rushed to the hospital. But Danny was already gone."

Stan wondered what powers were at work to relay to him the tragic tidings on that awful night, and he prayed that he might never be the recipient of similar messages again in the future.

Fortunately the Force's workload provided Stan a distraction from his pain. A trapper by the name of John Bishop, who lived near The Pas, was suspected of using strychnine in his baits. Strychnine was a particularly effective poison, causing quick death to any animal which ingested a bait containing the lethal additive. It was also the cause of a large amount of wasted fur, however, as even a small amount could kill several animals. All too often the

carcasses could not be located, hidden under a layer of fresh snow, and the fox and wolf populations in particular were suffering. Stan inspected the man's trap line and cabin, but found none of the illicit materials. He did confiscate two of the trapper's hides for analysis by the RCMP lab, however.

Playing a hunch, the constable then decided to check with the post office to see whether John had received any mail from the South. Post office records indicated that a parcel had been received via registered mail, and which had originated from a pharmacy in Moose Jaw, Saskatchewan. Word was relayed to Moose Jaw, and it was soon confirmed that the parcel had contained a supply of the poison.

Additionally, the police lab found traces of strychnine in the pelts Stan had forwarded. Stan assembled all the evidence for his superiors, but was reluctant to recommend that charges be laid as there was no direct proof of Bishop actually having used the compound. Nevertheless, the Crown attorney decided to proceed with the case.

A few short days later Bishop arrived in town for his trial, accompanied by a lawyer who had earned a reputation for surgically disassembling the prosecution's case on an all-too-regular basis. Heading into court, Stan was less than the epitome of confidence, having real doubt that the circumstantial evidence he had accumulated would result in a successful conviction. The magistrate asked Bishop's lawyer if he was prepared to enter a plea on behalf of his client.

"We are, your honor," the lawyer replied. "My client pleads 'guilty' to the charge."

Stan was more than surprised to hear those words, but he did his best to hide his emotion.

Once sentencing had been pronounced, he approached the attorney to inquire why he had given in without offering so much as a token defense. The lawyer admitted that he too had done some checking into the record of his adversary. By his reckoning, Stan's cases were so thoroughly researched and documented that he felt there was little use in contesting whatever would be presented at trial. He shook the constable's hand, and suggested that Stan's reputation was beginning to become as well respected as his own. Stan accepted the compliment somewhat sheepishly, not mentioning that in this particular instance, reputation had likely out-

weighed the facts by a good margin. Generally speaking, though, he was grateful that the lessons learned from such men as Les Ferguson, Charlie Klapecke and Dinty Moore had apparently helped to turn him into a competent policeman.

Throughout his stay in northern Manitoba, Stan had come to love all aspects of his new career. He much preferred the relative isolation to the congestion of city life, and he enjoyed the outdoors and the physical challenges which the job provided on an almost daily basis. Most of all, he was drawn to the people who inhabited a part of the world which many others might judge to be too harsh and unforgiving to bother with. Their spirit, selflessness and hospitality outshone anything which might otherwise attract him to a more "civilized" post.

The Force paid the princely bonus of one dollar per day for Northern Service. Most would have agreed that his current post was "North" enough already but, strangely, it was the RCMP's interpretation that the term applied only beyond the 60th parallel, that invisible line of latitude which divides most of Canada's provinces from the Northwest Territories and the Yukon Territory. For many good reasons, and one mildly selfish one, Cst. Byer volunteered in early 1944 for Northern Service.

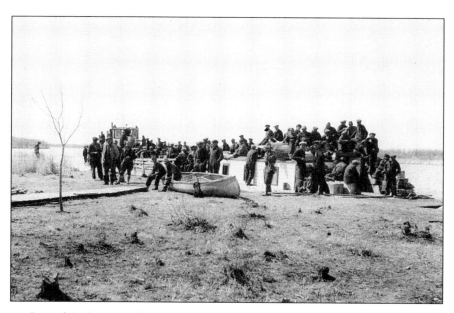

One of the barges of Tom Lamb's fleet. They were often loaded beyond their apparent safe capacity.

Back on "Rat Patrol" in May of that year, Stan encountered Tom Lamb returning to his muskrat ranch by barge, the S.S. Skippy "L," named for his daughter. (With typical Lamb humor, Skippy, whose job it was to keep the vessel clean and tidy, had placed a notice adjacent the door to the head. The note read, "We aim to please. You aim too, please!")

Tom had an urgent message for Cst. Byer; he was to return to The Pas immediately for reassignment to a detachment by the name of Arctic Red River.

The policeman had a solitary question for the boat's captain.

"Where the hell is Arctic Red River?" he asked.

He would have his answer soon enough.

Chapter 4

Refreshed from a two week leave in Saskatoon, Stan arrived in late May, 1944, at Waterways, Alberta, near what is now the much better-known city of Fort McMurray. After a 10-day delay at Fort Chipewyan for the Slave River ice to leave, he continued by Northern Transport Commission Limited barge north to Fort Smith, where ice held the barge back another two weeks. The journey proceeded through Great Slave Lake in the NWT, west across the lake to the Mackenzie River, and west and north again on the Mackenzie to Arctic Red River. Stan arrived at his destination 38 days after beginning the trek, joining Cst. Stuart Rook already stationed there. Canadian International Airlines currently flies from Edmonton to Inuvik, which lies 50 air miles north of Arctic Red, in about three hours.

Cst. Byer poses prior to departure on the Northern Alberta Railway, the first leg of his trip to Arctic Red River.

Arctic Red River is a tiny settlement laying on a piece of land which juts into the confluence of the Mackenzie River and the river for which it was named. For untold years, it served as an anonymous, temporary encampment where the

45

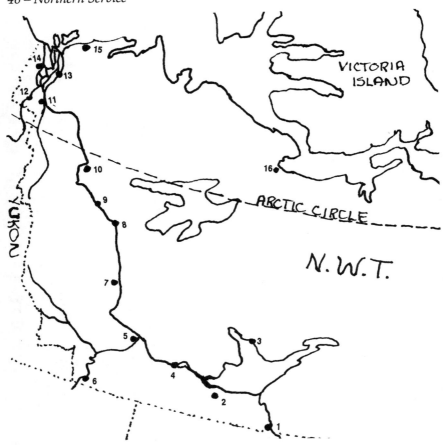

1 – *Fort Smith (on the Slave River)*, 2 – *Hay River*, 3 – *Yellowknife (on the edge of Great Slave Lake)*, 4 – *Fort Providence*, 5 – *Fort Simpson*, 6 – Fort Liard (on the Liard River), 7 – Wrigley, 8 – Fort Norman, 9 – Norman Wells, 10 – Fort Good Hope, 11 – Arctic Red River (at the confluence of the Arctic Red and Mackenzie Rivers), 12 – Fort McPherson (on the Peel River), 13 – Inuvik, 14 – Aklavik, 15 – Tuktoyaktuk, 16 – Coppermine.*

Native population of the Mackenzie Delta would gather to take full advantage of the excellent fishing. In the early 1900s, or so the story is told, the Roman Catholic and Anglican residents of Fort McPherson had a falling out, and it was decided that the Catholic population would re-settle at Arctic Red, 30 miles east and slightly south.

Accompanying Stan on his trip by barge were the detachment's new dog sled and its single annual shipment of fresh supplies. Each

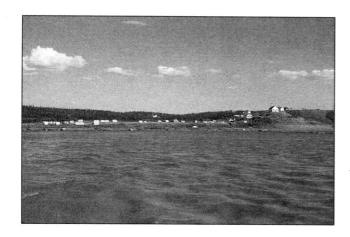

The community of Arctic Red River. The RCMP detachment buildings are part way up the hill, centre frame.

of the two men had been allotted 30 dozen eggs, 80 pounds of potatoes, and one case of oranges. Also among the provisions were one bottle each of rum and brandy. The bill of lading clearly identified these last items as for "Medicinal Purposes Only."

The fresh eggs and produce obviously would not keep for an entire year, so much of these goods were forwarded to the Hudson's Bay store or to Bill Clark, an independent trader, for sale to the local population, which numbered approximately 75 during summer months. The food would be replaced a fraction at a time from the three or four shipments received over the summer by the stores. By the fall of the year, fruit and vegetables were either of the dried or canned variety. Fresh meat was never a problem, however, supplied by way of gifts from local residents, or via caribou hunted by the constables themselves. And there were always whitefish, herring, pike or loche just a fishnet away.

The RCMP detachment comprised most of the permanent structures to be found within the settlement. Their quarters was a solidly built and well insulated 24 by 28 foot, four room cabin. There were also a 12 by 24 foot storage shed, and a second cabin which was utilized for more storage. The Hudson's Bay store, managed by Louis Desjarlais, who went by the surname of "Roy," and Bill Clark's store, each having a warehouse, and a few year-round dwellings made up all but one of the other buildings; standing predominantly atop a small hill, the highest point in the settlement, was the Roman Catholic mission.

There was a small lake, approximately a half acre in size, adjacent the settlement. Local legend had it that, many hundreds of years earlier, Inuit raiding parties would prey on Indians living in

The Hudson's Bay warehouse, behind which can be seen the small lake in which legend has it that the Indian residents of Arctic Red River once disposed of invading Inuit from the north.

Arctic Red. Before one such raid, it was told, the Indians received word of the Inuits' impending arrival. Banding together, they surprised their attackers, throwing the bodies of their defeated enemy into the lake. In all the time Stan was to spend in the settlement, no Native resident of Arctic Red River ever took water from that site, believing it to be haunted.

Early on, the two policemen decided on a schedule of housekeeping duty, alternating cooking and the fetching of water, and laundry and general cleaning on a weekly basis. Firewood for cooking and heating had to be gathered, but this was not simply a matter of wandering the "back forty." This was a job for both policemen plus local men hired for the occasion.

Each spring they would travel south upriver for a distance of 120 miles along the Mackenzie to collect driftwood, logs and lost lumber deposited along the river's banks by the departing ice. By

The RCMP office and quarters at Arctic Red River. One stack of wood is for burning over the course of the upcoming winter, while the other is left to cure for a year.

the time they reached their home post, they would have assembled something on the order of 70 cords of wood onto a crude raft, which they navigated back down the waterway.

As much of their patrol duty occurred in winter months (primarily because many of the months in Arctic Red River are of a wintery nature!) high on their list of priorities was the caching of rations at select camps along their patrol routes. Their post was responsible for an area extending to the Arctic Circle 125 miles south to Little Chicago on the Mackenzie, 150 miles along the Arctic Red River to the southwest, west to the Yukon border, and to the Mackenzie's east branch 25 miles to the north.

The constables were required to prepare and store sufficient food for their dog teams, as the commercial feed did not provide a full complement of the animals' nutritional needs. A half ton of whitefish, netted during the summer months, was dried, smoked so that it would not spoil and put up in 55 pound bales. Also available from the rivers was a variety of fish called inconni, similar in appearance to a whitefish, but growing to six feet in length and weighing as much as 70 pounds. Inconni was excellent as dog food all year round, and quite palatable to humans when caught in early spring. Supplies, consisting of the dried fish, meat and commercial dog food, were transported by boat and left at strategic intervals for use later in the year, securely stored inside boxes fashioned from heavy timber.

Patrols were made monthly into Fort McPherson, traveling a total of 22 miles down the Mackenzie to the mouth of the Peele River, then up the Peele to Fort Mac. Visits were made to the outlying residents along the way. In the settlement of Arctic Red River, the RCMP conducted surveys of trappers as to the number of animals taken and deposited with the local fur traders. As well, they issued permits to the Native populace for the trapping of beaver. The quantity of beaver allowed depended in part on how long a trap line each trapper operated, and the size of his family.

Some members of the community remained suspicious of the RCMP, given the antics of one of the Force's representatives a few years earlier. One of their men stationed in Arctic Red had been asked to store the furs collected by a trapper from the northern end of his trap line. After paying the fees required for the pelts, the trapper continued south upriver to gather the balance of his catch. Upon his return, he found that the policeman had sold the pelts as

his own. The trapper had no way of proving the theft, and had no recourse but to accept the loss.

Louis Roy, however, could not accept that an RCMP officer would stoop to such behavior, and he reported the thefts to the policeman's superiors. Similarly to the incident in Manitoba involving the game warden, the constable was merely transferred to another post. Failing to learn from his error, he repeated the scheme while assigned to a detachment in the Arctic Islands. He even went so far as to transport the skins on the RCMP ship St. Roch. The man was found out once more, however, and in fact had been serving a three month long sentence in the RCMP's version of Military Prison in Depot Division, Regina, while Stan trained at that same facility.

Nineteen forty-four was the first year of the federal government's Children's Allowance program. Constables Byer and Rook were responsible for registering each family within their territory, and for the subsequent distribution of vouchers, which could only be exchanged for foodstuffs or materials deemed related to the requirements of child rearing. Arguments were successfully made upon occasion that the replacement of a dilapidated canoe or sled contributed directly to the welfare of a trapper's family.

Arctic exploration by petroleum companies was also underway in 1944, and Imperial Oil had stationed a survey team at Arctic Red River that summer. The team and the two police officers had become quite friendly with one another, enjoying games of bridge or cribbage and other diversions.

In the fall of that year, the Imperial crew was becoming less and less comfortable in their tents. Awakening in cold and darkness, they would dress hurriedly before daring to exit what little shelter the tents provided and going about the business of attempting to discover oil deposits.

Stopping in for a cup of hot coffee one afternoon, the crew chief complained that the cold was wreaking havoc with his rheumatism.

"I'm all cramped up like you wouldn't believe," he related to the constables. "Every joint in my body aches, and it's about all I can manage to walk straight up."

The policemen were sympathetic, but unable to offer any real remedy to their guest. Disheartened, the man shuffled awkwardly from their building.

The pair of constables discussed for the next few hours what relief they might be able to recommend. There was no doctor closer than a full day's journey, and the man was obviously in a great deal of distress. Concerned, Stan walked down to the crew's camp to inquire of any possible improvement since he had last spoken with the man. There had been, indeed. In fact, it seemed the man had made a complete recovery.

"Damn fool," one of the crew offered. "He went for a leak a few minutes ago, and he figured out he's got his fresh long-johns on upside-down and inside-out from getting dressed in his sleeping bag this morning."

Stan pondered the possibilities; wearing skin tight, one piece, full-body underwear in that particular configuration just might produce the results described, after all. In any event, having corrected the alignment of his undergarment, the crew chief was feeling much better now, thank you.

By November, final preparations for winter had been completed. Fourteen-inch thick blocks of ice, to be melted and used for cooking and drinking water, were cut from a small lake behind the police post and stacked adjacent to their living quarters. The wood floated downriver that summer had been dragged to their station by the dog team, cut to length, split and stacked to cure and dry until it could be used the following winter. The current year's wood supply had been given similar treatment 12 months earlier. Finally, the dogs themselves had to be prepared for the enormous amount of travel to be made over frozen routes. Endurance training began with the wood haul uphill from the riverbank to the detachment, and escalated to a 16-mile round trip run. By mid-November, the team was making the return leg of eight miles in 35 minutes, pulling a well-loaded sled.

The detachment prepared for the yearly visit from the Inspector resident in Aklavik Subdivision. Minor discrepancies in paperwork or procedures received little notice, while postage stamps stenciled with the initials OHMS (On His Majesty's Service) were meticulously counted for any discrepancy with the written inventory. The stenciling was in place to demonstrate that stamps had not been "borrowed" and later replaced with those not bearing the initials, a most serious offense.

Annual inspection: (l. to r.) Insp. Kirk from Aklavik, an unidentified friend of Comm. Woods, Cst. Byer, Cst. Rook, Louis Cardinal, Commissioner S.T. Woods, Superintendent Martin, O/C "G" Division.

Having equally grave consequences was any variation between accounted and actual dollar amounts in the detachment's cash contingency fund, used to purchase emergency supplies and to pay additional help, such as Special Constables appointed from among the local residents. No such discrepancies were found in either case, and the detachment was given a passing grade.

Arctic clothing was supplied by the Force. That which was to be used by Cst. Byer, however, was far too small to be of any good against severe weather. As well, the bedroll he was to utilize on patrol was tattered and torn, and sufficiently dirty that Stan would not have it. The problem was that these were the only such items in the detachment available to him, and the Force was not about to replace "perfectly serviceable" issue. Instead, he would have to pay from his own pocket the expense of a new parka, mitts and mukluks. These were "made to order" by some of the women living in Arctic Red, and proved much superior to anything the RCMP had to offer, new or otherwise.

Similarly, Stan spent better than two months pay at Bill Clark's store for a new Woods eiderdown bedroll. Backed with virtually waterproof canvas, and lined with heavy wool blanket material, the goose down-filled bedroll was ample protection from the worst elements an Arctic winter could throw a person's way. The latter purchase was one well made, for not only did the sleeping bag serve him throughout his Northern Service, but it remains in use today, looking as fresh and new as the day he bought it.

In Aklavik, the outgoing Inspector had planned an ambitious patrol from his home base to Dawson City in the Yukon Territory. To assure success, the Inspector commandeered the best of Arctic

Red detachment's sled dogs, leaving less fit animals in their place. Cst. Byer had already completed two long distance patrols by dog team as the new year approached, and none were anticipated for the foreseeable future. Thus, there was no reason to believe that having these dogs would be a problem. Shortly after the officer left, however, word was received of the death of Bob McBride, a trapper, at his cabin 110 miles from Arctic Red River. George Hurst, another trapper who had found the deceased man, two Special Constables hired for the trip and Cst. Byer set out.

At noon, four days later, the team arrived at the cabin. Hurst had been unable to open the door when he first found the dead man. He had constructed a makeshift flashlight using a candle and a tin can, and then peered in through McBride's window, seeing the body inside. Stan managed to force the door, which had been wedged shut by a steel survey stake bearing the warning of a 100 dollar fine for its removal. McBride's body was sitting on the lower bed of his double bunk within the tiny cabin. In his right hand, still held close to his mouth, was a pipe filled with unburned tobacco. His left hand rested in his lap, a spent match laying on the blanket between his legs.

In order to properly access the cramped quarters and carry out a proper inventory of McBride's belongings, it was necessary to move the frozen body to the top bunk. Additionally, in order to bury the remains, the corpse had to be thawed and laid flat. In the confined space this was not easily done but, with some difficulty, the body was finally propped on the upper bed.

Stan called over the two Specials.

"We need an area thawed out large enough to dig a grave," he told them. "See if you can get a bonfire going, and if you can find enough scrap lumber around, maybe you could build a casket, too."

The two men went about their task while Cst. Byer lit a fire in the wood stove inside. Once the fire was going, he began collecting and listing all the trapper's papers and possessions, packaging the lot for the return trip to Arctic Red. The eight by ten foot cabin warmed rapidly, and Hurst prepared a meal of sandwiches. He poked his head outside, calling to the Special Constables, "You come in and get some grub whenever you're done with that casket."

The men hired for this trip were efficient workers, and after a few minutes one of them, Nicolas Norbert, opened the door, anxious to warm himself. Strangely, he did not enter the little cabin. Instead, he stood wide-eyed, mouth agape, staring wordlessly at some horror he could not vocalize to the two men inside. About the best he could manage was a drawn out "Gaaahhh," or something similar. Then he slowly backed away from the door, closing it as he did so.

Stan sat mystified, perched on the edge of the lower bunk, having no inkling of what had frightened the poor man away. Suddenly it became apparent, as the thawing right arm and hand of Bob McBride reached nonchalantly forward and down, as if to steal the sandwich from the policeman's own hand.

Perhaps influenced by the reaction of Nicolas, Stan thought for a moment that perhaps Bob had come back to life, and he nearly threw himself out the window. Hurst howled, and once Stan had a moment to think about it all, he joined in the laughter.

After collecting themselves, Cst. Byer and George prepared McBride's body for burial by wrapping him in a sheet and laying him in the coffin the Specials had built. A modest service was performed, and the men decided to spend the night before beginning the return journey the following morning. Special Cst. Norbert declined Stan's invitation to sleep indoors that evening, opting instead to make himself a place to bed down among the trees, well away from the "haunted" cabin.

While Hurst resumed traveling his trap line, Stan and his hired help returned to Arctic Red River with McBride's personal effects and valuables. These would be shipped to the Public Trustee in Edmonton via the next monthly return flight from Arctic Red.

Nicolas must have often wondered whether the temporary work with the police was worth the effort and aggravation. On patrol later that same winter back from the Tutsieta River, he and Cst. Byer encountered trails drifted in by snow and wind. In fact, it was increasingly difficult for the dogs to locate and stay on the trails, and their travel time was unacceptably slow. Recalling a lesson learned in Manitoba, Stan turned one of his lead dogs (Pat by name) loose ahead of the rest of the party. If the theory was correct, a lone dog should be better able to find the trail by himself. He would then return to the team along the trail, and the team in turn would follow the fresh scent as far as they could. The process would be repeated until their destination was reached, or the original trail

became more clear to all the dogs. The tactic was a success, and eventually they got as far as Tree River, where they rested the night, only 55 miles short of Arctic Red.

The following day, with a clear trail, the men easily made their way to the cabin of a trapper by the name of Jim Nagel, who Stan wanted to see. The site was a mere eight miles from Arctic Red River. Anxious to continue, Nicolas went on alone while Stan visited. An hour later, his business complete, Cst. Byer began the final leg home.

His team was in high gear, racing across the frozen turf in complete darkness. One mile short of Arctic Red, the night was suddenly filled with screams and howls. Stan was catapulted from his sled, landing headlong into a snow bank. Startled but unhurt, he scrambled into the fray, almost desperate to determine the cause of the commotion. Amid a tangle of dogs, sleds and equipment scattered all about the place, Stan was astonished to find a cursing Nicolas thrashing at the bottom of the heap.

While Nicolas had been eager to get home, for some reason his team had opted for a leisurely pace. Stan's team had not only overtaken the slower group, they had actually run right over top of them, depositing the Special Constable under the whole ungodly mess. Both men conceded that the episode did not seem funny at the time, but each experienced difficulty in retelling the tale as the years passed.

Another of Stan's Specials, Rudolf Cardinal, had given his lead dog a particularly curious name. Many of the area's residents opted for traditional Cree names for their dogs, but others would give them a handle best suited to the animal's disposition or appearance. Thus, dogs having such names as "Stupid" or "White Paws" were not uncommon. Rudolf's dog was named "Hitler."

"Why did you give your dog a name like that?" Stan asked him upon hearing of it the first time.

Rudolf must have thought it a dumb question.

"I guess you never been near my dog," he answered. "He's kinda mean, and a little crazy, too," he explained, seeing as the constable apparently couldn't figure that part out for himself.

Getting back to Nicolas though, he did eventually get some measure of revenge. Stan had taken up the habit of smoking, but found that cigarettes froze in the 30 below zero temperatures and were rendered useless. He had noticed that his companions uti-

lized a kind of stubby little pipe while on the trail, and he promptly made a trip to the Bay store, where he treated himself to a handsome looking long stem pipe which bore the legend "Made in Great Britain" and a price tag commensurate with such an extravagant purchase.

On the first patrol after this acquisition, Stan settled among his trail buddies, prepared his pipe and lit up. Throughout the procedure, he had noticed the others speaking among themselves and smiling strangely when looking his way. He paid them no mind, thinking them perhaps jealous of his recent purchase.

After a few moments, he noticed that he was not getting anything out of the pipe. He attempted to re-light the tobacco, but once more he was unable to draw any smoke. The others were enjoying his confusion when Nicolas finally leaned over and tapped the stem of Stan's new toy with his fingertip.

"The spit turns to ice," he explained simply, and with all the diplomacy he could muster. "You need a short pipe so the hot tobacco keeps the tube open." He tossed Stan's useless smoking apparatus into the fire, then reached into his bag and handed him a newly constructed short stem pipe. "I made you this for a present, anyway."

It was not nearly as impressive looking as the imported model, but it was fully functional. Stan thanked Nicolas for the gift, then watched as his money slowly turned to embers in the campfire.

Chapter 5

There was no radio or other communications facilities in Arctic Red River when Stan arrived. Mail, both incoming and outgoing, was transported by the RCMP as a courtesy to the people living in the region. Part of the reason for visiting so many of the people while on patrol was to deliver or pick up mail. Ten scheduled flights per year arrived in Arctic Red. Whether on floats or skis, the Canadian Airways single engine Norseman used the river itself to land. Twice a year, when the ice was leaving and again when it was not yet firm enough to accommodate the weight of a ski plane, flights could not land at the settlement.

Other than the monthly flights, people, goods and information could only be transported by the river. The nearest wireless was at Fort McPherson, a day's travel west on the Peele River by boat or cross country by dog team. The radio was owned by the Hudson Bay store, and the manager never refused its use to anyone in urgent need.

Aside from maintaining the condition of the detachment facilities, police work within the settlement was very nearly all administrative in nature. The local population was entirely self-sufficient, feeding themselves from the land and waters, and selling fur to finance other requirements. No government assistance was either asked for or needed. Even the Children's Allowance was considered more a gift than a subsidy. On rare occasions, one of the elders might request that the RCMP hold another of the residents overnight, if that individual got a little carried away with his home brew, for instance. Incarceration consisted of having to sleep under

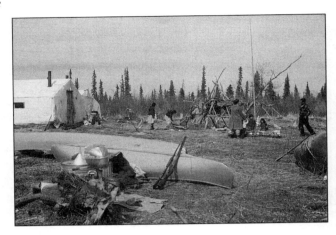

A family pre-pares for the an-nual muskrat hunt in the spring of 1947.

the detachment's kitchen table; there was no room elsewhere in the building, and no jail facilities existed at the post. With a winter population of 15 souls, trouble in Arctic Red was a scarce commodity.

Stan's second winter produced one of his most memorable adventures. The weather had been unseasonably warm, and promised to remain so for some time, when he was invited to accompany a party into Summit Lake, Yukon, to hunt caribou. Several hunters from Fort McPherson and elsewhere throughout the delta were embarking on their annual trip into the area where the animals congregated during their yearly migration. The caravan wended its way from Fort Mac down the Peele River and along the Rat River, finally arriving at a picturesque wooded hollow wherein they would camp near the lake.

The balance of the first day was spent making camp, and that evening Stan was treated to the most beautiful "music" he had ever heard. In total, 126 sled dogs were in the encampment. Wolves in the surrounding hills would call as they stalked the caribou herd, and the huskies would answer, creating a Nature's symphony unlike any other.

Stan's intent was to make a comfortable bed of spruce boughs and sleep outside during the three day camp. In typical northern hospitality, however, he was invited by his hosts to share space in one of the tents erected by the other 20 or so hunters. The invitation was something of a mixed blessing; the last remaining space was occupied by the wood stove. After waiting for the stove to finally cool, Stan had to remove it and the stovepipes, carry the assembly outside and then squeeze his tarp, bedroll and person into the tiny

empty space. It followed that the job of reassembly and making a fire at first light would also fall to him.

On the morning of the second day, Cst. Byer and a hunter by the name of Clarence Firth used a set of field glasses to check the surrounding hills for game. Spotting a large group of animals, they proceeded in a direction opposite from that taken by the balance of the party. In the hills and valleys behind the camp, Stan and Clarence took five caribou, a most successful hunt, in spite of one small incident. Stan had wounded one of the animals he had shot, and followed it almost around the hill so that he would not lose it, and the animal would not suffer needlessly. Clarence lost sight of Stan and fired his rifle into the air to signal his own position. Dragging the carcass back around the hillside, Stan picked that precise moment to find a small patch of ice hidden beneath a skiff of snow, and dropped flat on his back to the ground. Clarence saw the constable fall, and believed for one terrible moment that his shot had somehow gone awry. Stan waved to Clarence that he was alright, however, save for a bruised backside.

Using the sled dogs to drag the game to a central location, they dressed the carcasses and left them for pickup the following day. The other hunters were equally blessed with success, and the convoy of dogs and men began the return trip to Fort McPherson.

With the lack of roads and modern methods of travel, getting from one place to another often required ingenuity and innovation. At one particular point, a steep gully had to be traversed. The Native hunters felled trees along one side of the gorge, directing the fall such that a bridge was formed between the hillsides. Life in such an environment dictated that nothing ever be wasted. So it was that only enough trees were cut to permit a path sufficiently wide for a dog team to cross. Looking down on either side from their position at the rear of the sleds, the masters could see nothing but a 30-foot drop into the chasm below. The Native hunters made the crossing rather matter-of-factly, while the policeman was much less calm during the experience.

Where getting down the hill was a thrill-a-second roller coaster ride, getting the dogs and their heavily laden sleds up and over the nearly vertical, seven foot high embankment on the other side was pure work. First the dog teams were doubled for each sled, making a 14-husky power drive train per load. One of the men scrambled up to the top of the rise, and then signaled for the lead dog to follow. Reaching down from the top of the ledge, the man wrestled the

animal up and over. Grasping the traces, man joined with beast to pull the first set of two huskies over the ledge. Pair by pair the dogs clawed their way over until the sled itself was clear and free.

By the end of the trip the men would reflect on their good fortune, the fine weather, and perhaps even the incomparable scenery. Along the way, however, little came easily.

Travel schedules in the Arctic can be dictated by the elements. When the weather is foul, travel is delayed or put off altogether. In fair conditions, every attempt is made to take advantage of that window of opportunity. Stan had something of a reputation for stretching his luck while on patrol. One late summer evening, he and his guide were proceeding up the Mackenzie from Arctic Red. Barely enough light was available for them to see their way, and they could just make out the shoreline in what light was left. They concentrated on their route, the putt-putting outboard obliterating all distractions. All at once their boat lurched violently to the port side. Stan looked to find what had caused the problem, and saw the outline of a man standing against the deep purple sky.

About a half mile back and across the river, Hyacinth Andre, a trapper from Tree River, had shot a moose swimming in the water. He had struggled for hours to get the beast to shore without success when he saw Stan and the Special Constable go chugging by, oblivious to his calls for assistance. Hyacinth had jumped into his speedboat to chase down the pair, but unable to see any better than they could, he had broadsided their scow. Having long ago learned the lesson of "no harm, no foul," Stan and his Special returned to the carcass and helped Hyacinth retrieve it from the river, then dressing and butchering it. They were treated to a tasty meal of

Nicolas Norbert pilots the skiff on the annual wood gathering journey along the Mackenzie.

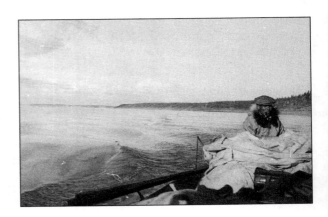

moose liver and fresh steak, then slept on the shore until daybreak. Their patrol had been interrupted, but not without reward.

Among the myriad of duties, responsibilities and voluntary undertakings performed by the RCMP in Canada's remote regions, the Force was often called upon by the residents to provide emergency medical and dental aid. Each detachment had a store of medicines, liniments and basic equipment to treat aches, sprains and strains. The advent of sulfa drugs to treat infection led to the local police post acting as a dispensary for these antibiotics. Novocaine was also inventoried to ease the discomfort of tooth extraction.

When not patching up the people or their animals, an Arctic Mountie may have been summoned to repair machines or equipment. Stan had become a competent mechanic while helping to run and maintain his father's trucks, and had no reservations in tearing down and rebuilding an engine when circumstances demanded. Electronics repairs was a different matter, but Harry Johnston, an independent trader at Tutsieta River, made such a request during one of the constable's visits. Harry had recently purchased a radio from one of his relatives, loaded it with fresh batteries, and looked forward to the broadcasts he would receive from the "Outside," as the urbanized South was known. To his dismay, the appliance failed to work.

"Why don't you see what you can do with this contraption," he invited Stan.

With no particular confidence in his ability to effect repairs, the policeman decided to give it a go anyway. It was not long before he found the probable source of the problem. One of the braided wire leads in the back of the radio had frayed and appeared to be shorting out. He repaired that flaw and, finding no others, turned the unit on.

Radio reception in the far North was haphazard at the best of times, dependent more on freak atmospheric conditions than any other one factor. Oddly enough, programs originating from station KSTP in St. Paul, Minnesota, found their way beyond the Arctic Circle as often as any others. After a brief scan of the AM band, Stan and his host were pleasantly surprised to home in on a signal emanating from the Canadian Broadcasting Corporation station in Edmonton, and the two sat back to enjoy music and news of the world. Instead, the station was broadcasting greetings from friends and relatives in Edmonton to the people of the North on its regular

Saturday feature, "Northern Messenger." Stan's attention was drawn to one message in particular, the text of which was along the lines of, "To my favorite Mountie, Stan Byer, stationed in Arctic Red River. Thinking of you always. Love, Jean Rafter."

It was a one-in-a-million chance that he had heard the broadcast. Jean's family had just recently moved to Edmonton from Gillam, and she had decided to try the service offered by the CBC. As far as Stan could ever determine, it was the only such message addressed to him during all his years in the North. Fate was having a further say in the development of this relationship.

Stan spent the early spring and summer of 1946 on temporary assignment to Aklavik Subdivision, operating the RCMP boat. He made regular patrols of the waterways south to Arctic Red River, on to Fort McPherson, and back to Aklavik. It was while on one of these patrols that Stan endured one of the more truly unpleasant tasks of his career.

A trapper by the name of Poole Fields, accompanied by his young son and daughter, was hunting for muskrat near Aklavik in the big channel of the Mackenzie. Their canoe overturned, spilling the family into the murky waters. Poole and his son managed their way to shore, but the girl, Phoebe, was not so fortunate. The survivors made their way into the settlement, where Cst. Ivan Thue solicited Stan's assistance in recovering the body.

For two days they dragged the river with grappling hooks. They were aided by the girl's distraught father, who hoped by some miracle Phoebe would be located alive. It was not to be. Fortune dictated that it was Poole Fields himself who would find his daughter's body. Wracked with grief, the man sobbed inconsolably as the boat made its trip back to Aklavik, his beloved daughter laying lifeless at his feet.

Chapter 6

While Cst. Byer loved the Arctic and its people, he found that its climate could be most cruel. Never was that so much the case as in the winter of 1946-47. Temperatures down to 45 below zero Fahrenheit were considered tolerable to work in. Beyond that value, however, the cold could cause serious damage to the lungs of both man and beast. Stan should have seen it coming. The annual shipment of supplies included a note that the detachment's contingency fund had been reduced by an amount equal to that usually required to employ help in gathering wood. Also included were 29 barrels of oil for the new stove the post was to receive. Missing, of course, was the oil stove. The final omen foretelling of a severe winter was the comparatively small amount of wood collected the summer of the previous year.

During one stretch that winter, the mercury indicated 55 below for several consecutive days. The settlement's remaining wood supply was adequate for the 15 or so residents, but there was nothing extra for the police stove. Stan and Cst. Bud Boyes, who had replaced Rook that summer, began to feel some concern about their predicament. Finally the weather broke enough that a patrol could be made. Cst. Byer was overdue in contacting Wright's Sawmill. The owner was to report the number of trees cut that fall so that stumpage fees could be calculated. That duty out of the way, Cst. Byer continued to Fort McPherson. The weather began to turn colder, but there was no alternative other than to go on. In Fort Mac, Stan was advised that the temperature was sitting at 60 degrees below zero.

The Bay store, second only to the local church as the focal point of any northern community.

Standing in front of the Hudson Bay store manager's fire, Stan noticed a pair of oil stoves in a corner of the room. The store manager advised him that the stoves were on the Aklavik store's manifest, but that the barges had been iced in before completing the trip downriver that fall. He contacted the Aklavik Bay manager by wireless radio and was told that the stoves had not been ordered by anyone in particular.

"They aren't spoken for," the manager told Stan, "so you're welcome to buy one, if you like."

The price was 130 dollars, but the policeman was not about to argue. After establishing that his credit was good, the only problem remaining was transporting the stove back to Arctic Red. Once more northern courtesy made itself evident, as the Canadian Airways pilot, Bill Cormache, offered to drop off the unit on his next flight. Just when that flight would occur, however, was in some doubt.

It was possible to keep aircraft flying in such weather by shrouding the engine in a tarp and lighting a gasoline fueled plumber's blowpot within the tent-like affair to keep the oil from freezing. Another option was to remove the oil and keep it indoors until just before the plane was to leave. Starting an engine with frozen oil invariably resulted in a seized engine. What was not possible was keeping the hydraulics from freezing once the aircraft was aloft. The hydraulics were necessary to control the pitch of the Norseman's propeller blade. A pilot with any sense would not take such a risk, and Bill Cormache was blessed with an abundance of sense. Stan returned to Arctic Red, slowly making trail through

bush which at least shielded him and his team from the numbing effect of the wind.

At last the weather improved enough to permit safe flight, and the stove arrived. With no tradesmen resident in the community, it was left to Stan and Bud to install the unit and get it working. That meant the wood stove would have to be removed first, and *that* meant no heat during the operation. Thankfully the living quarters had been competently constructed, and the insulation retained enough heat within the building so that the two could effect the renovation with a minimum of discomfort. With the new unit in place, the next chore was to get enough frost out of the congealed, diesel-like fuel oil so that it could be burned. One of the drums was turned bottom to top and the larger bung cap removed. Stan ran enough of the molasses-like material into a smaller container so that the stove's oil reservoir could be filled. With a sense of accomplishment and relief, the two policemen managed to get the stove to fire. Soon they were basking in the warmth of its petroleum-fueled heat. But the worst of that winter had yet to come.

The Canadian government's Environmental Services office in Ottawa had requested the assistance of the RCMP in recording temperatures throughout the Arctic. Each day one of the two constables was required to take three separate temperature readings. Environmental Services held a theory that differences in temperature existed within the settlement itself, at the shoreline and just above the surface of the frozen river. The entries made in the detachment's report would later suggest that no such difference existed. The temperature was found to be the same in all three locations each day. On one of those days, the reading was 82 degrees below zero Fahrenheit.

Many tall tales are told about the Arctic. Outsiders listen in suspended disbelief to stories involving ice worms, frost flies and temperatures so cold that huskies are commonly found stuck to a tree, frozen to death with one leg raised. Stan had heard a few such stories, both before and since his arrival in Arctic Red River. One evening during the week of 80 below zero temperatures, Nicolas Norbert called on the detachment office.

"Can I borrow a drum of kerosene?" he asked. "I want to keep a bunch of lamps going inside my house until it warms up some."

The policemen knew that Nicolas' dwelling was far less well insulated than their own.

"No problem, Nicolas," Stan answered. He retrieved a 10-gallon barrel from the storage shed, loaded it onto the man's sled, and Nicholas went happily on his way.

The next morning Nicolas was back to request a second drum. The police were well known for their generosity, but they were at the same time careful about being taken advantage of. Nicolas was the last they would expect to try such a stunt, but he could not possibly have used the entire 10 gallons in just one night, they reasoned, unless he had wasted several gallons somehow.

"I didn't waste none," Nicolas protested. "I never even used what I got from you last night. I couldn't get it out of the drum."

"Why didn't you ask to borrow our bung wrench, then?" Bud asked.

"Oh, I got the drum open OK," Nicolas replied. "But the kerosene's frozen solid, like everything else around here."

Stan had heard a similar tall tale from Tom Lamb back in Manitoba, and he dismissed this most recent incident as simply a case of water having been placed into the drum by mistake. He and Nicholas went outside to collect a second keg from the RCMP stock. Nicolas insisted that the constable check this container to ensure it contained the correct material. Reluctantly, Stan opened one of the bung caps. The first thing he noticed was an absence of the distinctive odor kerosene normally has about it. The awful possibility that the rest of their winter "fuel" consisted of kegs of ice briefly crossed his mind. Curious, he took a sniff closer to the container's opening, and could just barely detect the fuel's odor. He tipped the barrel a few degrees, but no kerosene spilled out. He then turned the drum fully on its side with the same result. Taking a screwdriver, he poked inside the hole he had just opened. The instrument made no intrusion on the rock-solid fuel. Stan apologized to Nicolas for doubting his word, and made a mental note to send a similar message to his friend back in Manitoba.

The extreme cold produced other phenomena. Air becomes much more dense with a decrease in temperature. That particular week in Arctic Red River, people had to either be very careful of what they said, or speak in hushed voices. Normal conversation would carry for better than one quarter of a mile in the outdoors. A person chopping wood could easily disturb his neighbors living a good distance away. Very little gossip occurred within the settlement for several days.

Life was comfortable enough within the detachment's living quarters. Once a week each man would partake of a relaxing soak in their rubber, fold-down bathtub. Peaceful hours were spent reading and playing cards, and visiting with the community's winter residents. The elements outside these confines were less hospitable, to say the least. Machinery froze solid. And the human body took cues from its mechanized counterparts.

It was inevitable that the men had to leave their living quarters two or three times daily to answer the call of Nature. It was on these occasions that the men discovered that in severe cold the body can behave strangely; certain processes can refuse to work in the customary fashion. To help cheat the body's reaction to the cold, the enterprising policemen constructed a simple device which proved invaluable that winter. A few pieces of one by six inch board were nailed together edge to edge, and a suitably sized opening was cut from the middle of the contraption. Next came a removable layer of thick duffel. The assembly would sit behind the stove absorbing warmth until the 15-yard sprint to the outhouse could no longer be delayed. There is a saying about the relationship between necessity and invention, and it certainly applied that winter in Arctic Red River.

The pages of the calendar were turned every 30 days or so, however, and as they were the realities of that winter began to fade into memories. In March of 1947 Cst. Byer met a man who had traveled 165 miles from his home near Snake River in the Yukon Territory in order to make a large purchase of groceries from the Bay store. The amount of provisions he had bought was considerable, and Stan expressed doubt that the man's dog team would be able to haul such a load. The trapper tried to ignore the advice, but the policeman insisted that he would accompany him to his home, his own team sharing the burden. Reluctantly the Native finally agreed, and with their sleds filled to capacity, they made the six day journey to Snake River.

Stan was invited by the man's family to rest and share in a meal, and to stay overnight before beginning the return trip home. Happily, he accepted their hospitality. The following morning, as they were finishing breakfast, an elder of the small community entered the cabin. In halting English, he insisted that it would be better if the policeman left immediately. Stan was certain he had somehow managed to insult his hosts, perhaps through ignorance of some custom or another. The elder reassured the young Mountie

that he had committed no faux-pas. It was simply a matter of, "Big storm come. *You* go."

Stan knew better than to dismiss the advice of a people whose ancestors had known the land and its ways for a longer period of time than recorded history could measure. He thanked his hosts and set out to the east, his sled empty except for his bedroll, some food, and spare clothes. Somehow his dog team sensed that they were going home, and they set a frantic pace. By nightfall, he had reached Bernard Creek, where he was the guest of a trapper and his family. A light snow was beginning to fall as he mushed his team onward early the next morning. As the distance between him and Snake River began to widen, the snow dissipated until it was once more a clear day.

The second night was spent at Marten House. As Stan approached the cabin belonging to a widow and her two young children, it became apparent that they were not home. Pots and pails of frozen water were inside the cabin, and no wood was available for a fire. He proceeded to gather and chop a significant woodpile, leaving the family a good supply of kindling and shavings in exchange for the use of their shelter. He arose early the morning of the third day, greeted once more by a gentle fall of snow.

Again Stan out-raced the weather, and he arrived in Arctic Red River later that same day. When he awoke after a long and peaceful sleep, a vicious spring blizzard was raging which would engulf the community for several days. "Big storm" had indeed come, and he was thankful for having received the warning. In the 14 years of service he spent with the RCMP in the North, that was the longest and fastest trip by dog team Cst. Byer would ever complete.

Fair weather finally arrived in the delta, and Stan was ordered to Aklavik Subdivision for a six week period, during which he was to overhaul outboard motors prior to summer patrols. Competition for furs was fierce among the brokers on the "Outside." Each spring Bill Levine, a representative of Edmonton Fur Auctions, would head north to Norman Wells via Canadian Airways' DC-3 aircraft, then catch the Norseman to Aklavik. His purpose was to distribute cash to independent traders, hoping to attract more purchases with hard currency than with credit against accounts which had increased in size over the winter. As the ski plane was unloaded that spring, Bill seemed more than a little nervous.

"I'm missing one of my bags," he said to the pilot finally, after going through the luggage several times. "You didn't see an extra one around, did you?" he asked hopefully.

The pilot hadn't, but he assured Bill that any baggage left over in Norman Wells would be forwarded later that day. Bill was sure he had seen the bag on the tarmac back at the Wells, and he could not imagine that he had left it behind. "I can ask the Corps of Signalers to send a wire to the Wells when I get to Aklavik," the pilot offered. "If it's that important to you."

"I'd sure appreciate it," the agent said.

True to his word, the pilot got word back to Norman Wells, where the bag was located, still sitting on the tarmac next to the passengers' waiting room.

Bill's relief was obvious when the case was delivered later that day. He carried the valise up to the RCMP building, and when he opened it, Stan had an opportunity to see more money than he would ever see again in one lump in his lifetime – 350 000 dollars! The agent was treated to a short draught of "medicine" to help settle himself.

While in Aklavik, Stan became acquainted with Mike Zubko, who was flying for Canadian Airways. Muskrat pelts were selling at six dollars apiece, and the local trappers were desperate to get their catch to market as quickly as possible to take advantage of the price. Mike saw an excellent opportunity for a charter air service. With some understanding of the transportation business and an ongoing love for aviation, Stan saw the same opportunity. Mike had recently ordered a two place Aeronca Champ, and Stan assembled whatever money he had not already spent on clothing, bedrolls and stoves, and purchased a used Piper Super Cruiser with the registration CF-EUB to round out the fleet. Together the two formed Aklavik Air Services, and it was Stan's intent to be a hands-on owner/pilot. This meant, of course, that he could no longer be a member of the RCMP. Accordingly, Stan mailed a letter in which he requested his discharge from the Force.

Cst. Byer returned to Arctic Red in time for the first arrival of the Hudson's Bay Company's summer barge runs. Among the vessel's crew was a young woman whom he recognized immediately. Jean Rafter had secured a position as chief stewardess for the Fort Smith to Tuktoyaktuk leg of the route. Their visit was short, but it obviously made an impression on the good constable. He would

A Hudson's Bay sternwheeler barge docks at Arctic Red, with Jean Rafter aboard as stewardess.

later comment to Bud Boyes, "Any woman who's silly enough to follow me to Arctic Red River deserves to be married to me!"

Chapter 7

Stan had one memorable trip by boat before his discharge papers came through. The Royal Canadian Corps of Signalers had set up a small radio station in Aklavik. Their broadcasts had limited range, extending only as far as Arctic Red and McPherson, but they offered music, news and messages. Neither Bud nor Stan particularly cared for the type of music that was played, and they rarely listened to the station. One morning one of the summer residents came into their post and told them there was an urgent message to the RCMP being repeated over and over. Stan turned on the radio, and sure enough the announcer was reading a bulletin which stated that the police were required in Ft. McPherson as soon as possible. No reason for their attendance was mentioned, but Stan and Nicolas Norbert jumped into the police skiff and made the 50-mile river trip. Half way there they decided to stop to boil a pot of tea and relax for a few minutes.

One of the less attractive features about the North is the number of insects which are present during the short summers. Moose were known to run from the blackflies and mosquitoes until they died from exhaustion. If they found water, they would wade in until only their snouts were visible. Stan thought he had seen the worst of it back in Manitoba when he had escorted a group of US Army officers on a tour of the Fort Prince of Wales on the north shores of the Churchill River. He had warned the men to bring repellent with them for their visit of the 18th century fort, and trusted that they would take his good advice. As he had nosed their boat in to shore, he called to one of the officers at the front of the boat to jump ashore with a line. As soon as the man's feet hit the

ground, however, a cloud of mosquitoes engulfed him and everyone else in the craft. All the men were choking on the bugs and wiping palmfuls of blood from the backs of their necks. The volunteer dived back into the river boat as his companions screamed at their guide to reverse course and get them out of there, pronto. Instead, Stan dug into a packsack and produced a supply of insect repellent, then returned to shore and conducted the tour in relative comfort.

The air was just as full of the little buggers now when Nicolas hit the shore. He took one look back at Stan before he decided that the tea could wait. Being eaten alive was too heavy a price to pay for a 15-minute rest.

When the pair did arrive in Ft. McPherson, Stan went directly to the Bay's manager, Bill Carson. Bill operated a wireless telegraph, and Stan thought him to be the logical choice to know what the urgency was. Bill had not sent a wire to Aklavik, however, and knew nothing of the emergency. Cst. Byer sought out the town's independent trader, but he had no idea of anything which required the services of the police. Finally, Stan went to the Anglican mission. The minister's wife was practically apoplectic, desperately relieved that the two policemen had made it at last. She demanded that Stan arrest Mike Kutko, the independent trader, and shut down his store immediately. What heinous crime was Mike accused of having committed? As she explained to the policemen the reason for this harsh action, the pair were dumbstruck. The woman claimed she knew for a fact that the merchant was selling prophylactics.

"He's selling what?" Stan asked.

"Prophylactics!" the woman screamed at him. "Rubbers! French safes! Whatever else you men might call the things. You do know what they're used for, don't you?" she bellowed. "The man's promoting fornication!"

Stan explained as politely as he could that no laws were being broken by the trader, and that there was nothing he could do about the situation. The woman insisted, threatening to report his inaction to higher authorities if he failed carry out his duty. Even the minister himself could not dissuade his good wife from her argument. Stan explained that Mike had a license to operate a store, and that he had no authority to close down a perfectly legal operation. He was about to suggest that the offensive items were in all likelihood available at the Bay as well, but thought better of making

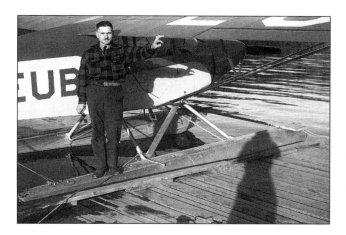

Temporarily a civilian, Stan poses proudly on the pontoon of CF-EUB, the Piper Super Cruiser he'd purchased to form Aklavik Flying Services with Mike Zubko.

a bad scene worse. After he had exhausted all other options, he promised to refer the matter to his superiors in Aklavik Subdivision at his first opportunity. Mollified at last, the lady retreated. Apparently Aklavik satisfactorily replied to the minister's wife directly, because Stan never heard any more about it. And Mike continued to sell condoms without further incident.

By August, Stan had received permission to leave the Force, and he returned north to reunite with Mike Zubko in Aklavik. A critical element in operating an aircraft for hire was, and continues to be, possession of a commercial pilot's license. That in turn requires the demonstrable ability to fly an airplane, one skill Stan had not yet fully acquired. So it was that in September of that year, Stan traveled to Edmonton to take three additional months of training as a pilot. Along with Carman Pearson, a far more experienced pilot, Stan ferried his newly purchased Super Cruiser south. The plane was on pontoons, which had to be replaced with skis for the winter season. As well, the prop's automatic pitch adjustment was behaving erratically, and this had to be corrected by engineers in Edmonton.

On the way, the pair stopped at a lake near Wandering River where Mike's parents lived. After a short visit, Stan and Carman prepared to leave. This was as good a time as any for the problem with the propeller to become more pronounced, and Carman tried several times without success to lift off from the water. With barely enough daylight left to get safely to Cooking Lake near Edmonton, Carman decided to go for broke, using the full length of the lake in a last-ditch effort to become airborne. The plane remained water bound, however, and ended up in the bulrushes at the extreme

northwest end of the lake. Stan discarded his trousers and jumped into waist deep water to extricate the Super Cruiser from the muck. As he climbed back in, Carman applied take-off throttle one more time. When he ran out of lake, he aimed the plane up a narrow stream, more determined than ever to reach Edmonton before nightfall. All the while Stan was struggling in futility trying to get his pants back on.

Suddenly the pilot called out in alarm for Stan to get his seat belt on – there was a bridge dead ahead of them, and there was no way they were going to avoid hitting it. In one final, desperate attempt to cheat fate, Carman hauled back on the control stick with everything he had. The sudden change in the plane's angle of attack did the trick, and the prop collapsed into fine pitch, sending the Super Cruiser skyward at last. As Stan watched the bridge pass harmlessly beneath them, the only thing on his mind was the question of what the crash recovery team would have thought at finding a half-naked body in the wreckage of his Super Cruiser.

Stan was understandably rattled by this close call, and had little to say for the remainder of the trip. When Carman suggested that he should keep a lookout for "wet spots in the summer fallow," Stan didn't even bother to ask why. Carman knew how much fuel was left, or more correctly, how *little* fuel was left after all their abortive attempts to take off back at Wandering River, and he wanted two sets of eyes open for a place to put down if bad came to worse.

Finally, Cooking Lake lay in front of their plane's nose, and Carman began a descent straight for the body of water.

"You should call us in to the pattern, shouldn't you?" Stan inquired, wondering why the pilot had not used the radio to advise other aircraft of their approach to the lake.

Carman picked up the microphone and broadcast, "If there's anyone around Cooking Lake, look out for Piper Super Cruiser Echo-Uniform-Bravo. We're coming straight in on a heading of one-seven-oh degrees." He jammed the mike back onto its clip, looked over his shoulder briefly and asked, "Happy now?"

Stan surmised correctly that his companion was not, and chose not to correct Carman on his less than "regulation" broadcast.

They made it into Cooking Lake, unpacked their gear and called Mike's brother for a ride into the city. Just as they were ready to leave, Stan had the bright idea to dip the fuel tanks. Carman

protested the move, suggesting that if Stan wanted to sleep that night, he would be better not to know.

Returning the following morning to write up the service order for the engineer, Stan allowed his curiosity to get the better of him. He climbed up to the wing and inserted a wooden dipstick into the port side wing tank. It was dry. He then measured the starboard tank, already knowing what he would find, insofar as Carman had been flying with both tanks turned on simultaneously. This bladder had barely enough avgas in it to wet the tip of the stick. Opening the engine's cowl, Stan realized that by the time they had tied up to the dock, the only fuel on board was the one pint within the collecting tank above the carburetor plus whatever was in the fuel line itself. He was glad he had waited to look.

Later on Stan would be told by the engineer who worked on the plane that the apparent problem with the automatic pitch was actually caused by the engine's tachometer, which read 250 revs faster than it was actually going. At take-off power, or an indicated 2750 rpm, the prop should have automatically adjusted to fine pitch. The blade's speed was actually only 2500 rpm, well short of the required power. It was good luck, the engineer told him, that the plane ever got airborne. Stan figured that on the last take-off, Carman must have just pushed the throttle to the firewall at the last instant to actually get the propeller turning at the necessary 2750 rpm.

Stan began his flying school classes almost right away. Many hours were required in class learning navigation, meteorology and the theory of flight. In addition, more time was required at the controls of a trainer aircraft. One so completely wrapped up in intensive studies should have had little spare time, but Stan somehow managed to find enough of the precious commodity to get down to some serious courting of the lovely Miss Rafter. The two agreed that after he had become a little more famous, and a lot richer, they too should form a partnership. Stan now had a new incentive to succeed in his venture with Mike, and after earning his commercial license, he prepared to return to Aklavik, ready for the challenge. The return trip was no less an adventure than that in to Edmonton that past fall.

Carman once more accompanied Stan. After overnighting in Fort McMurray due to weather, they took off in zero ceiling conditions the next morning, getting only a few miles farther along before having to stop once more at an emergency airport at Embra

Portage. They fared better the next day, flying as far as Fort Providence, NWT, before being weathered out again.

They arrived in Fort Simpson the following day, stopping to top the fuel tanks. A twin engine Anson freighter operated by Yellowknife Air Services was in Simpson having skis fitted, and Stan and Carman leant a hand in the chore. There was no weather service to provide a report on conditions further on in their route, but both pilots concurred in an eyeball assessment of acceptable skies. Not far away, however, low cloud demanded that Stan descend to a mere 30 feet above the river in order to make any progress. Forced to spend the night at an abandoned trapper's cabin, the intrepid duo set out once more the next day.

They only got as far as Fort Wrigley when they were forced to land again. They met up once more with the Anson's crew there, and tried to make the best of a frustrating situation. A light snowfall required that the wings and fuselage be cleaned prior to attempting to take off, but the Anson's pilot was so upset by the delays that he dismissed Carman's concerns about sweeping off the tail surface. Anxious to get underway, he decided that the wind would take care of any snow left on his aircraft. Stan and Carman took off ahead of the larger plane, but Carman insisted that Stan circle the airport until the Anson was safely away. He did not really expect the other plane to become airborne, and wanted to be in a position to help when the inevitable occurred.

The freighter's nose was aimed skyward during its run down the airstrip, but the plane never achieved the required lift, and it plowed into the bush at the end of the field. By the time Stan and his partner landed, the Anson's four man crew, mercifully uninjured, was assessing the damage. Stan and Carman promised to get word to Canadian Airways in Norman Wells and have them send another plane to pick up the stranded crew. With Carman now at the controls, they took off again, and awhile later Stan wrote a note in the back seat of the Super Cruiser while Carman patiently circled the settlement of Ft. Wrigley, which was located a few miles from the airport and across a river. The note was tied to a stone Carman had picked up from the ground back at Wrigley, and with precision the envy of any bombardier, Carman tossed it out of the window and right into the yard of the Bay store manager. They continued to circle until they were satisfied the note had been found and, with a wave of their wings, they headed north once more.

Poor weather resulted in their taking a full two days to get as far as Fort Good Hope. There was a wireless there, and they sent a message to Aklavik inquiring as to the status of the weather further on. The one flaw in this otherwise intelligent decision was that in mid-December, there was no daylight by which to see a horizon in Aklavik. Whoever sent the reply, however, assessed the conditions as clear. Needless to say, they were not, and Stan had to once more resort to "steamboat" flying mode, skimming the surface of the river until they arrived at Aklavik. Mike Zubko met the pair at the airstrip, and suggested that he was more than a little surprised to see them.

"How did you manage to find the town?" Mike asked, explaining that Aklavik had just gone through a week and a half of weather that no one else had dared to fly in, and that this was without question the worst day of the ten day stretch!

"We flew IFR," Carman offered.

Mike knew the plane had no instrumentation of any sophistication, and besides, Aklavik had no beacon on which to home.

"You flew Instrument Flight Rules?" he asked, wondering if perhaps he had heard incorrectly.

"No," Stan answered. "I Follow River."

Stan and Carman were just happy to be safely home at last, with themselves and their airplane intact. The journey had taken them a week to complete after leaving Edmonton for the "routine" flight northward.

Where fate had been helping Stan's love life along quite nicely, it was not being nearly so kind relative to his business aspirations.

A splendid winter day at Aklavik. The frozen waters of the Mackenzie provided a winter road throughout the delta.

Inspector C.N.K. "Nordy" Kirk, O/C Aklavik Subdivision, pilots the motor vessel Aklavik.

During his three months in Edmonton, the price of muskrat pelts had dropped dramatically, fluctuating between 65 and 85 cents apiece. At that rate, it was no longer economically feasible to transport them by plane, and Aklavik Air was in trouble. With sufficient business to support only one pilot, Stan elected to hand over his share of the fledgling company to Mike.

For the next several months, Stan made his living as a mechanic and equipment operator in the small community, and he came to know the RCMP Subdivision's Officer Commanding, Insp. C.N.K. "Nordy" Kirk, on a more personal level. As well, Henry Larsen, captain of the RCMP vessel St. Roch which was icebound at Herschell Island north and west of Aklavik, would stop in at the Subdivision's offices between trips outside to Ottawa over the winter. Both knew of Stan's misfortune, and together they suggested a possible remedy. If Stan were to re-enlist, Capt. Larsen would take him on the St. Roch as an engineer.

Stan thought the suggestion over, and decided it was the best of any alternatives he had yet considered. In March of 1948, he approached Insp. Kirk, who advised him that the next mail plane out would leave the following morning. There was no sense in waiting another month, they decided, and got to work filling in the appropriate forms, finishing at midnight. Stan included a letter which requested that he be assigned to Air Division after serving on the St. Roch. Six weeks later, Stan was Constable Byer once more. The move did not make him rich, although it did prevent him from becoming any poorer. It was Mike, however, who achieved some degree of fame.

Mike Zubko (r) and Cst. Stewart by Mike's half of Aklavik Air Services, a tiny Aeronca, CF-BRD. Imagine six people crammed into this craft, as was the case during Mike's rescue.

That same summer, while Mike was still flying his tiny Aeronca around the delta, a brush fire had erupted that was threatening the area 20 miles northeast of Arctic Red River, scorching its way toward Caribou Lakes. One family lived on a point jutting into the lake, and had no means of escaping the rapidly approaching danger.

The amount that an Aeronca Champ could carry was severely limited by its very size and design. On pontoons, that limitation was even greater. The family Mike had to evacuate consisted of a woman and her four children. Including Mike as pilot, but with no other option, six people made the journey from the summer camp to Arctic Red. According to the books, the flight was simply not possible. And in the opinion of the Air Transport Board, the flight was sufficient grounds to consider canceling Mike's license.

Unbelievably, someone had seen fit to report Mike's heroic act as little more than an unnecessary and dangerous stunt, and Mike was summoned to provide a formal account of his actions to the Board. With his livelihood on the line, he calmly explained to the investigator that while the aircraft was "technically" overloaded, he had been low on fuel, which allowed some leeway in how much he could carry inside the craft. Apparently the investigator found merit in this explanation, because Mike continued in business for another 40 years. The question of how Mike could possibly have had sufficient fuel for the *second* part of that trip apparently was not a factor in the ruling.

After dropping off the woman and her children, Mike had returned to the camp, having just minutes to load six huskies inside the cabin of the float plane, and to strap the family's sled onto the

pontoons before once more returning to Arctic Red River. It had seemed to Mike that a trapper would be more than a little disadvantaged without his means of transportation, so he had repeated the hazardous mission, effectively achieving the impossible twice on the same day.

In honor of Mike's many contributions to the North, the airport at Inuvik was named for him in 1995, a year after he succumbed to cancer.

Chapter 8

Stan spent the first three and one half months of his second stint in the RCMP much as he had the previous spring, conducting river patrols. On July 29th, true to his word, Insp. Larsen summoned Stan to Tuktoyaktuk where he would join the crew of the St. Roch. Being transferred aboard the St. Roch was a dream come true for Stan, for the ship was legitimately a part of Canada's history.

By 1928, the RCMP had had detachments at Herschel Island and Fort McPherson for a quarter century, yet depended on chartered ships for the re-supply of those posts. The St. Roch was launched in the spring of 1928, the Force's own floating detachment and supply vessel. For the next 12 years the ship was used to transport men and supplies back and forth from the Arctic, and to police Canada's sovereignty in the far North.

In 1940 it was decided that a voyage through the Northwest Passage to Halifax, Nova Scotia, would reinforce that sovereignty, and the St. Roch left Vancouver harbor in June. She was captained by Henry Larsen, who was then a sergeant. For over two years the St. Roch fought nearly impossible odds. Icebound for a total of 22 months during that time, the ship and crew spent nearly an entire year trapped at Pasley Bay near the magnetic North Pole before breaking free and sailing into Halifax a month later. She thus became the first vessel in history to travel the Northwest Passage west to east.

Two years later the St. Roch was assigned the task of repeating the voyage, but from the opposite direction. Taking a route farther to the north through Lancaster Sound, Larsen completed the 7300

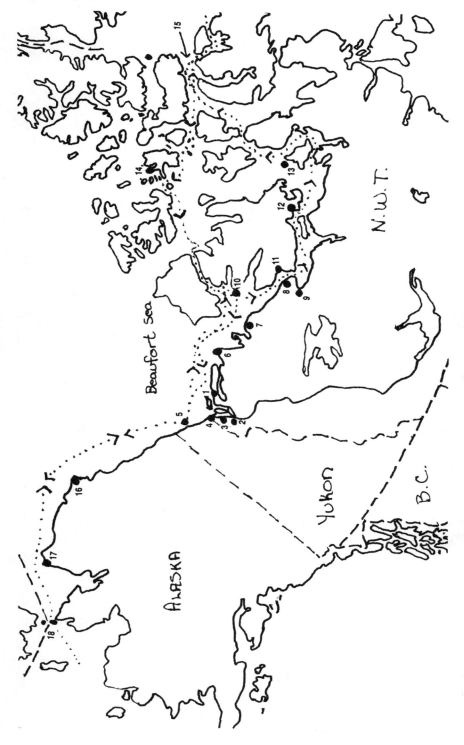

Facing Page: dotted line represents routes taken by Larsen and the St. Roch during the historic trips of 1940-42 and 1944. 1 – Tuktoyaktuk, 2 – Fort McPherson, 3 – Aklavik, 4 – Shingle Point, 5 – Herschel Island, 6 – Baillie Island, 7 – Pearce Point, 8 – Bernard Harbor, 9 – Coppermine, 10 – Holman Island, 11 – Read Island, 12 – Cambridge Bay, 13 – Site of Franklin's death, 14 – Magnetic North Pole, 15 – Lancaster Sound, 16 – Point Barrow, AK, 17 – Port Hope, AK, 18 – Diomede Islands in the Bering Strait.

mile long Halifax to Vancouver trip in a mere 86 days. At the conclusion of this voyage, Larsen was commissioned as an Inspector.

Duty over the next few summers was more routine, relatively speaking, and the spring of 1948 brought orders to re-supply the Hudson's Bay Company's warehouses in the western Arctic. The Bay's own ships had been unable to break through ice from the east, and its stores in Coppermine, Holman Island and Reid Island faced a bleak season. The Hudson's Bay duplicated their orders and had them shipped to Edmonton and north through Waterways for transport by barge to Tuktoyaktuk on the Beaufort Sea. From that point, the St. Roch would assume the responsibility of getting the goods through to their ultimate destinations.

The St. Roch at Tuk harbor, taken by Harry Heacock as he taxied away after dropping off Stan and other new crew members. (Courtesy H. Heacock)

Larsen had wintered the ship at Herschel Island, making the odd trip by air to Ottawa. By mid-summer they were ready for the current season's assignment, but only after considerable effort. At one point that spring, the St. Roch had been taking on as much as 5000 gallons of water a day owing to damage incurred the previous year, and the crushing effects of being trapped in ice over the winter. Pumps ran constantly for several weeks until repairs could be made, and the hull's planks swelled enough to seal the leaks.

On July 29th, Stan boarded the RCMP Norseman CF-MPF, flown by Harry Heacock, and was transported from Aklavik to Tuktoyaktuk along with three other members, a meteorologist and an observer from the Royal Canadian Navy, Lieutenant K. Boggild. The Navy observer had the duty of recording ice conditions in the Arctic waters, confirming the location of both new and known landmarks, taking soundings and charting the route along the way. Despite the numerous trips Capt. Larsen had made in those waters, navigation was still hazardous. Earlier, he had overflown the routes with Harry Heacock.

"We flew over from east to west," Harry said, "and we went over that shallow water, and he took a look at that and he was just mumbling to himself. He had no idea how many shoals were in there. It was calm water and he could see right to the bottom, and it was just a labyrinth."

Henry Larsen, captain of the St. Roch.

Stan had never been aboard a ship the size of the St. Roch, but stepping from the gangplank to the deck of the 104-foot long, 80-ton schooner, he was amazed at how stable the craft felt in the water. He was secretly relieved to find none of the swaying motion that he had expected. Stowing his gear at the direction of the chief engineer, Corporal "Burt" Bur-

ton, he commented on the firm footing.

"Well, rookie," Cpl. Burton explained amusedly, "it just so happens we're grounded until the tide comes in. Once another three and a half feet of water gets under us, it'll seem more like you're on a ship than a sidewalk."

Stan could feel his cheeks begin to glow.

"I think I'll go freshen up a little," he offered weakly, anxious to escape Burton's grin.

In addition to being the ship's purser and detachment officer, Stan was assigned duty as the ship's third engineer. The ship was scheduled to depart for Coppermine later that evening, so Cpl. Burton took Cst. Byer on a whirlwind tour of the engine room, introducing him to the idiosyncrasies of the 300 horsepower, six cylinder Union diesel engine which powered the vessel. This particular engine design was different from smaller diesels to which Stan was more accustomed. The Union engine employed what was called a "Common Rail Injection System" where the fuel lines were connected directly to the injectors, and the injectors were actuated by rocker arms off the camshaft. A constant fuel pressure could be maintained through the use of independent fuel pumps. In the more conventional system, the pressure is created almost entirely by the compression stroke of the pistons as the engine is turning. The "Common Rail" innovation resulted in more consistent power, but required far more attention from the engineer.

What Stan found more curious was that a machine 10 feet long and seven feet high was rated at a paltry 300 horsepower. He found it particularly odd that the engine could never be revved beyond 300 rpms, else the bearings would suffer extensive damage, yet the full rated horsepower was achieved at 350 revolutions. He accepted the unit's differences and continued the tour. Next he was shown the magnetic clutch which linked the propeller shaft to the engine. This feature permitted the prop to stop turning should it hit ice, while allowing the engine to run on. Had a direct mechanical linkage to the engine been in place, the prop and drive shaft would be damaged instantly upon hitting a solid obstacle.

Cpl. Burton explained that gauges had to be routinely checked, cylinder temperatures monitored and recorded, and preventive maintenance performed. The engine room also housed an auxiliary diesel, which served to run the main engine's air compressor. Additionally, this secondary unit ran the generator which main-

tained the ship's double bank of batteries at full charge. The St. Roch had a 110 volt, direct current electrical system powered by the batteries, and it was explained to the new engineer that a constant output was required to keep the gyro compass in proper working order. Without the gyro, accurate navigation was nothing more than wishful thinking.

Shortly after seven that evening, the St. Roch was underway, its 13'6" draft barely clearing the harbor's 14 foot deep base. The ship was forced to follow a serpentine route in order to maintain clearance above the harbor bottom, and it did not take long for Stan to learn what it really felt like to be aboard a seagoing vessel. Getting his sea legs was the first order of business.

The schooner and her crew encountered heavy ice scattered along the intended route, and within 24 hours they had to anchor at Big Booth Island harbor due to a thick fog which blanketed them. It was not until four the next afternoon that they could proceed once more, and the delay prevented them from inspecting the RCMP post at Pearce Point.

Near midnight of August 1st, 15 miles out of Bernard Harbor, the ship was approached by a group of Inuit who were camped at the abandoned settlement. They reported poor hunting, but appeared generally well, and the St. Roch continued to Coppermine, arriving at nine the following morning. Even with the assistance of the two constables stationed there, it took two full days to off-load and distribute their cargo, which was consigned to the Hudson's Bay store, the Department of Northern Affairs and the Coppermine RCMP detachment itself. Additionally, the St. Roch had transported building supplies for the construction of a new school and nursing station. After he had completed checking off the manifest, Stan enjoyed the hospitality of Canon Webster and his wife, who together operated the Anglican mission.

On the return trip to Tuk, the fog was often so thick that the crew could make no visual references to guide them. In situations such as this, they were required to continuously take soundings of the water's depth by hand line, comparing the readings to charts in order to pinpoint their location. Near mid-afternoon of August 7th they were back in Tuk, taking on fuel and 113 tons of cargo for transport to Reid and Holman Islands.

This journey was thankfully free from ice floes, however, thick fog and strong northeasterly winds caused them to once again anchor for a day inside the harbor at Big Booth Island. Much of

Lt. Boggild plots longitude and latitude as Reid Island residents look on.

their load consisted of bulky freight, which could not be lowered into the hold and had to be carried above deck. The winds had resulted in an enormous amount of water and spray, which in turn had found its way into the ship's forward quarters through the skylight and door. Much of the short layover was spent putting these quarters back in order, and drying out clothing.

A day and a half later, the St. Roch anchored at Reid Island, really little more than a gravel bar rising from the water's surface. The only permanent structure on the island was the Bay store. No trees or other vegetation were to be found, yet the Inuit population treasured their home for its excellent seal hunting.

Not all of the St. Roch's cargo was destined for the Bay, however. Left off here as well was a 12-year-old boy named Joe Uwena. Joe had lived at the Anglican hospital at Aklavik since the age of two, when he had severely injured his leg. The government had ordered that the youngster be transported home but, after ten years away from the customs of his people, Joe was ill prepared for his return. Asking the crew how he could be expected to eat raw seal meat after being brought up in western ways and manners, the child cried for hours before finally agreeing to rejoin his family.

While the ship's cargo was being unloaded, Lt. Boggild busied himself taking new readings of the harbor to correct erroneous charts. Stan's duties as detachment officer called for him to record the vital statistics of the settlement, any births, deaths or marriages which had taken place since the RCMP had last called in. Insp. Larsen accompanied him on his visit with the people living there, and together they found the inhabitants to be in excellent health, with good supplies of seal meat as food for both themselves and

their dogs. The ship took on a cargo of 6200 pounds of fur bound for Tuk, and early the next morning the schooner left Reid Island for Holman. Enjoying excellent weather, they arrived at their destination just before midnight of the same day.

Here again Stan visited everyone at the settlement to gather the statistical data which was the responsibility of the Force. There was even an opportunity for a social call with an old friend from Churchill. The Holman Island Bay store manager, Billy Calder, was most appreciative of the efforts expended by the RCMP in salvaging his season. So thankful was he that he treated the crew to more than a little libation. It apparently was his convention that a guest's glass should never be empty of rum, or at least not for more than a few moments at a time. Some of the crew tested that custom to extremes, among them the detachment officer. How could a ship have seemed so steady, Stan wondered, when an entire island could rock and sway like a leaf in a breeze?

To what degree his acceptance of Calder's generosity contributed to the seasickness Stan experienced the following day was a matter of much good-natured debate in the weeks that followed. There is no question that the weather turned most foul, which certainly caused some of his discomfort. Stan could not avoid his shift below decks despite his illness, and unknown to him, bits of insulation from their first cargo of building materials had been washed into the bilges by water overflowing the deck. In his altered state of mind and body, he failed to notice that the filters on the bilge pumps had become clogged with the material, and the water had soon risen within the engine room up to the bottom of the diesel's flywheel. Rudy Johnsen, the second engineer, and Cpl. Burton came to his rescue, clearing the filters and using hand pumps to remove the water which had accumulated. Cpl. Burton was gracious enough to admit that he had not warned Stan of the consequences of clogged filters during their tour back on July 29th, but the balance of the crew took great delight in blaming their "near sinking" on the new engineer.

Relatively calm waters permitted the crew to return to good health on the trip back to Tuk. Another 106 tons were loaded, almost exclusively for the Bay in Coppermine, and Stan's third voyage began August 21st. The St. Roch had in tow the RCMP boat Cambridge Bay, a 28 foot, diesel powered vessel destined to be dropped off at the location for which it had been named. The weather was moderate, but the presence of ice floes prevented the

ship from proceeding with any haste, lest the Cambridge Bay suffer damage. Their caution was not rewarded, however, and the smaller boat was buffeted by the floating ice. Thirty-five miles east of Baillee Island, the ice disappeared, only to be replaced by snow and high winds. It was apparent that the "Bay" needed repair, but the sea was too rough to allow the crew to bring her alongside for boarding. Passing Bernard Harbor, Capt. Larsen decided to seek shelter there and effect repairs to the "Bay."

The damage had been primarily restricted to the propeller shaft and rudder. The latter item had become unhinged, but fortunately it had entangled in ropes hanging from the boat's stern. As well, the railing around the forward deck had been loosened and bent by the St. Roch's tow rope. Repairs were quickly made, and the crew loaded empty drums and checked the cache of aviation gasoline left at Bernard Harbor for refueling the Force's aircraft. Before they could leave, they were approached by three Inuit families from Coppermine. The eight people were in ill health and without food, thus the decision was made to transport them and their dogs back to their home, where they arrived 10 hours later.

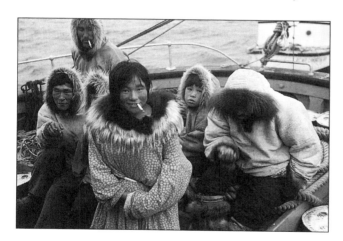

"Tailor-mades" were a favorite gift among Northern residents. Here, a family hitches a ride aboard the St. Roch.

A most impressive sight greeted the crew in Coppermine. The salmon run was on upriver and the beach was lined with rack upon rack of Arctic char split for drying and smoking. Capt. Larsen quickly had two empty barrels and several bags of salt dispatched from the ship's stores, and a barter was hastily arranged to trade for the delicious fish.

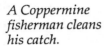
A Coppermine fisherman cleans his catch.

The crew was also surprised to run across Joe Uwena, whom they had last seen at Reid Island, and who greeted them now as old friends. The boy had not been able to adjust to Inuit life back at Reid Island, and had been adopted by the Websters and moved to Coppermine. The lad was obviously far happier than when they had last seen him, now feeling quite "at home" despite the change of address.

Before leaving Coppermine, some of the crew took empty drums up the Coppermine River and filled them with fresh water for the return voyage to Tuk, Herschel Island and, hopefully, beyond. This trip to Coppermine concluded the St. Roch's obligations to the Hudson's Bay Company, and Larsen did not want to winter the ship again in the Arctic. It was his opinion that the vessel was in need of a refit, and he hoped to make Vancouver before winter weather could eliminate that possibility altogether.

After two days at sea, the St. Roch came across the marine vessel Fort Ross, and the two ships accompanied one another westward. On arrival at Franklin Bay, they found the waters thick with old ice blown there over the past week by high winds from the north. Good progress was made for several hours, until dense fog prevented them from seeing the leads, or gaps, between the individual floes. With nowhere to go, the two vessels moored to one of the floes by means of securing their smaller anchors to the ice. Over the next few days the ships would break through to leads whenever possible, and moor when it was not. Snow, sleet, rain and fog reduced visibility to as little as 200 yards, obscuring passages out of the jam. By September 1st, concern was growing about the

proximity of the ice floes, and the possibility of having to double back away from Tuk loomed large.

Daybreak on September 2nd brought an eerie surprise to the less experienced crew members peering through the dense fog which enveloped the St. Roch. The sky was aglow with a pale rose-colored haze, a grand departure from the stark white sky which had surrounded them for days. One of the deck hands called on Capt. Larsen to come and see the phenomenon for himself, but once the commanding officer was on deck, all hell broke loose.

The skipper raced to the wheel house and frantically began calling orders and signaling for engine power. What appeared as an unexplained celestial occurrence was in fact the glow from a natural coal bed named Smoky Mountain. Because of spontaneous combustion, the coal deposit was perpetually afire, and Larsen recognized that his ship had been pushed adjacent the shore by the relentless wind and ice. It would not be long before the St. Roch would be crushed between the two unyielding masses.

The crew worked with the desperation of doomed men. In the engine room, Stan and the other engineers were continuously called upon to first provide full forward power, and then to abruptly reverse the direction of the ship's screw as the skipper crashed the sturdy vessel back and forth into the ice seeking a lead.

By midnight they had escaped the danger. The ship inched its way towards Tuk with the Fort Ross in close pursuit. Eventually, only scattered chunks of ice impeded their way, and those to no great degree. By 11 p.m. September 3rd, they were at the entrance to Tuk harbor, where they bade farewell to the Fort Ross and continued on towards Herschel Island.

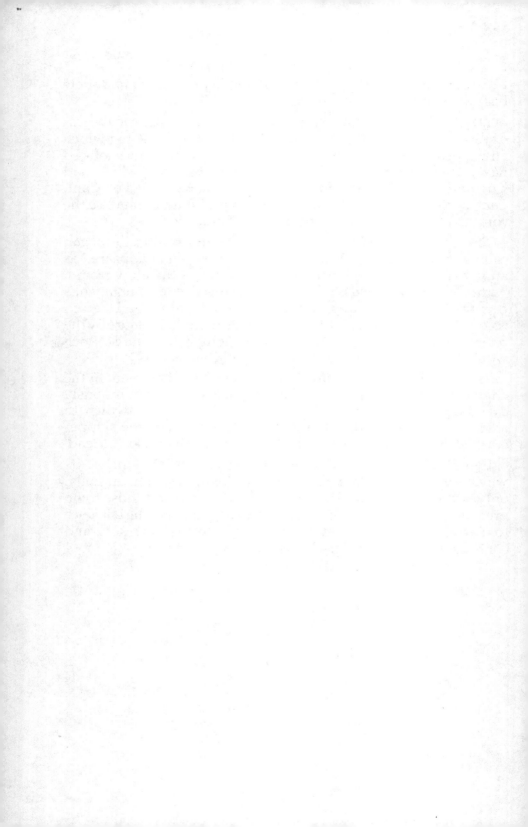

Chapter 9

Within 18 hours Larsen was questioning his decision to go on. The ship was constantly surrounded by ice, making little headway and being forced to simply drift along in the thick, soup-like fog. They were moored to an ice floe six hours out of Herschel, between Shingle Point and King Point, when the weather broke. A hand scrambled up to the crow's-nest atop the 67-foot main mast, and dejectedly reported that all he could see, from horizon to horizon, was pack ice, which the St. Roch stood no chance of penetrating. They remained tethered to the floe for another 36 hours, giving consideration to doubling back to Tuk once they were again able to follow leads. The leads did become open, but in the direction of Herschel Island, so the order was given to proceed westward.

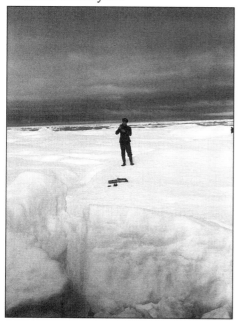

Lt. Boggild confirms the ship's position. Note the depth of the crevasse to the lieutenant's right. Ninety percent of an iceberg lies below the surface.

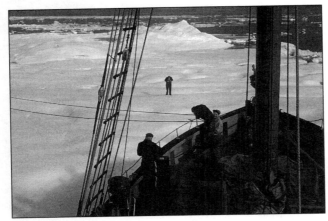

An unidentified crew member snaps a picture of the ship and a few of his compatriots.

Capt. Larsen was as stubborn as he was capable, and on arriving at Herschel he directed the crew to make preparations to leave for Vancouver. Primary among those preparations was the checking of the engine, which had endured considerable strain because of the ship's continuous battle against ice floes during their recent voyages. Every available empty drum was filled with sea water and lowered down into the hold to act as ballast against the rough seas which they would undoubtedly encounter along the route to the west coast port. The ship and crew were ready; all they were waiting for was favorable sailing conditions. Larsen hiked to the highest point on Herschel so he could scan the horizon for ice. He did not have to look far, as the ice was packed in tight against the north and west sides of the island. On September 9th, however, a strong wind rose from the east, blowing the pack ice out to sea and clearing a way for their departure.

They set out at noon that day, making good progress through the leads until they reached Demarcation Point, where the winds abruptly reversed direction. The crew came upon a floe grounded in 55 feet of water and moored to it for 16 long hours before they could get underway again. For the next day and a half they followed precariously close to the shoreline, sailing in as little as 15 feet of water by the time they reached Point Barrow, Alaska. There, they contacted the US air base by wireless and requested that all available lighting, both at the base and on the point as well, be turned on so that the shoreline could be determined with some degree of confidence. By two thirty a.m. on September 13th, the ship cleared the last of the ice that they would meet. Their way would be far from placid, however.

For the next two days the St. Roch and her men endured gale force winds out of the west south-west. Virtually no distance was being made, and there was little respite for the crew. Capt. Larsen anchored on the south side of Port Hope spit, waiting out the storm in the comparatively calm waters. Shortly after they dropped anchor, they were approached by a pair of 24-foot long skin boats. The Inuit occupants invited the crew to visit with them and their families in their settlement. Trusting the Natives' skill in handling their unsophisticated looking water craft, Larsen permitted as many men as could be spared to go ashore.

Their hosts presented the men with a grand tour of Port Hope. Most intriguing to Stan was the burial ground, which demonstrated the settlement's history as a whaling community. The burial grounds were surrounded by a fence made entirely from whale bones. The main archway into the sacred land was comprised of what Stan felt must have been the largest non-fossilized skeletal remnants on earth. Also included on their tour were a well-kept school, nursing station and trading post. The men of the St. Roch were warmly received by every family living in the tiny village, and they were most appreciative for the diversion from their tedious journey.

The grave marker of a Peter Koonuknoruck, 1876-1941, towers over those of his companions in life's last adventure.

The next day was spent in preparation for what promised to be an arduous sail through the Bering Strait. Capt. Larsen warned the men that the going would not be easy; they would have to navigate in shallow waters, well out from shore, splitting the Diomede Islands. But not even he could have predicted the extent to which Mother Nature would test the ship and her crew.

Almost immediately after departing Point Hope, the ship was assailed by fierce

weather. Despite hail and snow which hindered navigation, Larsen pressed on. At one point the weather broke momentarily, and Lt. Boggild took a reckoning. Capt. Larsen did not like what he heard in Boggild's report. Two years earlier, while returning to Vancouver, the St. Roch had strayed into Russian waters in heavy fog. Capt. Larsen spent one night as a "guest" of that country's government, and it was an experience he especially did not wish to repeat. According to the Navy man, they were north and west of the Diomedes, in exactly the same spot as the ship had been in 1946 when that ugly incident had occurred. Little time was lost in putting the Russian coastline behind the St. Roch this time, although the already tired engine was pushed to the limit of its remaining capacity in making an escape.

The next leg of the trip was to prove the most hazardous of all. A gale from the northwest brought with it a steady storm of snow and sleet, but visibility was becoming the least of their problems. For five straight days the St. Roch was assaulted by huge waves. The water was so high that it would enter the ship's funnel and be routed down and into the engine room, spilling over whichever unfortunate engineer might be on duty at the time. The forward crew quarters were rendered unusable, as the men who bunked there simply could not enter the fo'c'sle because of the massive amounts of water washing across the deck.

Not that anyone could make use of a bed without tying himself into it. If someone tried to sleep on a bunk, he was simply flung out and onto the deck by the action of the waves. In the radioman's quarters, a receiver was torn from its place on the wall and was hurtled across the room, landing harmlessly on the empty mattress while the operator tried to sleep on the floor. Had he been in the bed at the time, the result may well have been more serious. In the engineers' starboard side cabin, a washstand was ripped from its anchors and reduced to kindling. There was a pendulum style indicator on the wall of the engine room which was graduated to 45 degrees in either direction. For five days the pendulum swung beyond the last mark and back again in a monotonous routine. If not for considerable luck and the righting effect of the drums of water as ballast in their hold, the St. Roch certainly would have capsized.

Tools were scattered and tossed into the bilges, and sea water drenched everything aboard. Cooking a hot meal was entirely out of the question, only partly because the galley's contents had been

deposited on the floor of the ship; keeping a fire going in the stove was an impossibility. What food was consumed during the ordeal came out of a can, although few of the men could keep any food down. The entire crew, save for Rudy, was ghastly ill, and the demon rum had nothing to do with any of it this time. Rudy attributed his relatively good health to simply having experienced all of this before. Some of the crew feared they were going to die, while some others prayed for the moment to arrive.

In the early afternoon of the 22nd of September, the crew began to notice that the nauseating pitching to and fro' had begun to recede. The pendulum in the engine room hung more or less vertically, and Stan raced on deck to see the weather for himself. They were within sight of land, and the delighted crew rejoiced in the knowledge that in just a short while they would be in the safety of Dutch Harbor. Within an hour, however, the seas began to roll once more, and another hour after that brought the typhoon-like winds back to their full strength, straight into the St. Roch's bow. The aft sail was deployed off the mizzen mast to keep the ship on a straight tack heading into port. It would take them another 24 hours, with a partially crippled engine running at a mere 95 rpms, to travel the last three miles into Dutch Harbor.

Lt. Boggild commented that from what he knew about the laws of the sea, which was a considerable amount, the St. Roch had no business being afloat. He was not alone in that assessment. While docked, they were advised that the winds at sea had remained quite constant, varying little from a measured average of 110 knots per hour for the better part of the last week.

Capt. Larsen kept the ship in port for five days. The crew had much work to do in reassembling the interior of the St. Roch and making it livable again. Stan and the rest of the engineering team had to get their area back to ship's standard, and the tired engine back to its best possible condition. The bearings in particular had taken a severe beating, and were reassembled as best as could be managed with a very limited inventory of spare parts. After these repairs were concluded, Larsen called Cst. Byer into his cabin.

"I want you to go into the contingent account," he said, "and take whatever American money we have and go shopping."

"Shopping, Skipper?" Stan asked. "What do you want me to pick up?"

"Clean the place out," Larsen told him. "I want you to buy all the fresh eggs, milk, meat, fruit . . . whatever you can find, as long as it's fresh!"

Stan managed to collect a full 200 dollars in American funds, and the ship's cook prepared a feast fit for a king with the groceries Stan assembled from his trip ashore.

On the evening of the 26th, there was call for a celebration of another sort. It was the occasion of Stan's 32nd birthday and, with the knowledge that they would have a full day during which to recover from any overindulgence, the crew made their way to the local tavern for a proper party. The barkeeper did not disappoint them, seemingly having learned his trade from the same person who had taught Billy Calder back at Holman Island. An impromptu rendition of "Happy Birthday" was sung by the entire crowd assembled in the pub. Although little regard was given to either tune or tempo, the effort was greatly appreciated by the constable.

The proprietor of the bar had a present in store, but it was to be shared among the whole crew. It seemed that this particular pub had entertained every St. Roch crew that had ever passed through Dutch Harbor, and the owner had yet to accept money from his Canadian friends. He should have enforced the closing time, however, as this particular group was drinking not only to party, but also to forget their experiences of the past week or so. By three thirty in the morning, most of the men had found their ship, and at least some of these managed to land in their bunk on the first try.

The next 11 days were spent slowly inching their way southward. Numerous times the ship was forced to anchor to wait out fog and rough seas, but progress was being made. In the late afternoon of October 8th, they moored at a commercial wharf in Murder Cove, Alaska. The place had come to be known by that unfortunate name for good reason. Several years earlier, a man had been hunting from his small boat when he noticed bushes along the shoreline moving in an unusual way. He raised his rifle and emptied its magazine into the bush. Upon inspecting the scene, he discovered that he had shot and killed a man who was merely out for a walk along the seashore.

There was an island nearby which was known to Larsen for its excellent deer hunting. Stan was given a rifle and told to collect fresh venison for the ship's larder. The shore was a tangled mess

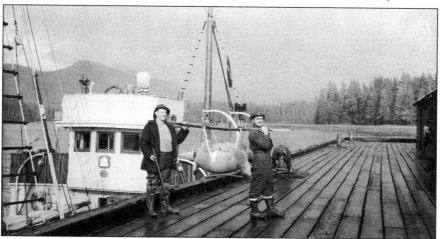

Cst. Byer and Cpl. Burton with fresh game collected on the trip home. The venison was a welcome treat in comparison to the canned goods which were the staple diet aboard the St. Roch.

of driftwood standing several feet high, and the constable had great difficulty walking atop the entwined tree limbs. Jumping down onto the sand below, he soon found deer tracks and proceeded to follow them. In short order, he also discovered the paw print of a bear.

He placed his own foot next to the paw print, and found that his size 10 boot would have fit neatly within the impression. As he stared at the print, it dawned on him that water was seeping into the indentations the animal's foot had made in the sand. That meant that the beast had been there only a few moments earlier than the policeman had.

"Sweet Jesus," Stan mumbled to himself.

He scrambled to the top of the driftwood pile, and did not miss a single step on his hurried return to the scow left on the beach a hundred yards back. Larsen intercepted him as he clambered back on board the St. Roch.

"Any luck?" he asked expectantly.

"Sorry, Sir," Stan lied, "there's no deer on *that* island."

"Of course there are, Constable," Larsen said. "Now go back and get one." Stan obeyed the order reluctantly, eventually managing to find a good-sized buck without being found himself by the bear.

At nine-thirty p.m. on October 18th, the St. Roch docked at the Evans Coleman Evans wharf in the port of Vancouver. The following eight days were occupied with cleaning the ship to a suitable condition before continuing on to Esquimalt, B.C. One of Stan's last duties aboard the St. Roch was typing Capt. Larsen's report of the ship's travels and duties that season.

By November 1st, Capt. Larsen had arranged a refit for the battered and bruised schooner. In 1950 the ship would sail from Vancouver to Halifax by way of the Panama Canal, making the St. Roch the first ship in history to sail completely around the continent of North America. In 1954 she returned to Vancouver, having more than earned her retirement from service.

The St. Roch is currently a National Historical Site in the city of Vancouver, giving proud testimony to the contribution of the RCMP in the development of the Arctic. On a recent trip to visit his old ship, Stan obtained a photocopy of the lengthy report he had typed almost a half century earlier. That report forms the basis of much of the preceding two chapters.

Chapter 10

By November 1st, 1948, Stan had received word that his request for assignment to Air Division had been denied, without further explanation. His orders read that he was to report to "K" Division, Edmonton, Alberta. After a few weeks leave, he arrived for duty in Alberta's capital city.

Very little of the RCMP's work actually took place within Edmonton itself, as the city employed its own police force. Aside from performing checks on applicants hoping to achieve the status of naturalized citizens, the Force's jurisdiction lay primarily in the various surrounding communities, such as Spruce Grove, St. Albert, Jasper Place and Leduc. As Leduc grew with the expanding petroleum industry, that town warranted its own RCMP detachment very shortly after Stan arrived in Edmonton.

Stan did have one item of unfinished business within the city, however. In early December, he petitioned the Force for permission to marry, and it was granted to him. In those years, members required the approval of the Force before they could be married. The reasons for this policy included the perceived need to run security clearances on the proposed spouse, and to ensure that adequate accommodations existed where the Force provided them. As well, the salary of an RCMP officer was adjusted to match the added cost of supporting a family. On New Year's Eve, Cst. Stan Byer and Jean Bernice Rafter were joined in matrimony.

Duty in Edmonton was very different from that Stan had become used to in the North. Time was far more regimented, for one thing. When unoccupied with any particular investigation, each member

could turn to one of the 100 or so files he held regarding citizenship applications. Weekends were often taken up by assignments such as being on call for out of town dances, festivals or rodeos. These were considered part of an RCMP officer's normal routine, with no overtime pay or time off in lieu. Stan always knew an RCMP officer was considered to be on duty seven days a week, 24 hours a day, but this was the first he had seen it in practice!

It was not unusual to finish a shift, only to be advised that a prisoner escort to some federal penitentiary had been assigned, perhaps as far away as Prince Albert, Saskatchewan. An RCMP officer crossing provincial borders had to be wearing full dress uniform, so a quick trip home was first on the agenda for a change into red serge and Stetson, the uniform which universally symbolizes the RCMP. Policeman and convict would arrive in Saskatoon by train in the late evening, continuing the journey by midnight train to Prince Albert. Custody did not transfer until the prisoner was physically handed over to prison authorities, so escorting officers had to wait until a duty officer arrived at the prison. Then it was back to the railway station for the return trip to Edmonton via Saskatoon. A sleeping berth was provided for the ride west, and the officer took advantage of it because he knew he would be right back to his regular shift when he arrived home.

One escort duty involved Stan's being partnered with Cst. Tom Auchterlonie, who had been with the St. Roch just before Stan was assigned to the ship. Two men were on trial for murder in Edmonton, and the pair of constables first accompanied them to Alberta Hospital, where they were held for three weeks of psychiatric observation, and later to Ft. Saskatchewan, Alberta, where the sentence of execution by hanging was carried out after their ultimate conviction. The condemned men were given their leave of this world in a manner as equally distasteful as their crime. Standing back to back, they were hung from opposite ends of the same rope through a trapdoor specially modified for the occasion. All this was witnessed by the coroner's jury, and the escorting officers as well.

The execution took place at midnight, and after completing the required paperwork, the two Mounties drove back to Edmonton. When they arrived at the detachment a little after one in the morning, both were told to finish their shift before heading home, yet another seven hours later. This was typical of a routine that was becoming monotonous, but Stan was never one to complain.

One evening Stan was called to help at the scene of a horrific traffic accident just outside the city's boundaries. On the way there, he learned via the squad car radio that alcohol had played a part in the accident, so he made a quick detour to the home of a friend, Larry Naylor. Larry was a free-spirited individual, with a strong sense of invulnerability, and who would too frequently imbibe "happy juice" and then drive off from the tavern or party in a state of intoxication. Stan had tried unsuccessfully on numerous occasions to warn Larry of the chance he was taking, both of being stopped by the police and of killing himself. Larry was at home, so Stan invited him along for a short ride, which Larry innocently accepted.

Once at the scene, it was apparent that the accident was even worse than Stan had thought. Other officers had already given up hope of extricating any survivors from the carnage. Two sedans had met head-on at very high speed, and the front half of each was imbedded into the other. The smell of gasoline and whiskey hung in the cool evening air. Larry was immediately impressed with the site, but Stan wasn't finished with him yet.

"Come over here," the constable directed his friend, motioning to the pile of wasted steel and humanity.

"I don't think I want to," Larry said. It was obvious he was about to be ill.

Stan walked to where Larry stood ashen-faced, and drove his index finger into his chest.

"This is what happens to a lot of people who think they'll live forever," Stan said, "and then try to prove it. I don't want to be called out some night and find you with a steering wheel driven through your chest, and you're going to promise me it'll never happen, aren't you?"

Larry began to walk backwards from the scene, towards Stan's car.

"I promise," he said weakly. "I swear." Larry continued to enjoy himself for many years to come but, to the best of Stan's knowledge, he never again drove while under the influence of alcohol. Perhaps some good came out of the tragedy.

In the spring of 1950, an old friend came calling. Henry Larsen was now the Officer Commanding "G" Division, consisting of the Northwest Territories, the Yukon and all other points north of the 60th parallel. Insp. Larsen was in Edmonton on his way through

to the North, where he was about to launch a search party for the last location of Sir John Franklin's expedition, begun in 1845, to find the Northwest Passage. He told Stan that several openings were coming available in the North later that year, and invited him to apply for a transfer.

There were many attractive incentives to accept that invitation. Among these was the fact that members occupying positions in the North could expect to be promoted to the rank of corporal earlier than would normally be the case for their compatriots in more urban locations. And of course there was the matter of bonus pay and free accommodations. Thinking it would be nice to rebuild the bank account a little after his unsuccessful foray into the business world, Stan made out his application for transfer. At the end of May, he and Jean were provided seats aboard an RCAF aircraft, and together they flew north to Fort Simpson, NWT.

Chapter 11

Ft. Simpson was at that time a town of approximately 125 souls, built on an island at the junction of the Mackenzie and Liard Rivers. There was a hospital, a school, two independent trading posts, a Bay store and, just 10 miles away, an airport. A 10-man contingent of the Royal Canadian Corps of Signalers operated a wireless relay station there, an important communications link between Canada's North and the outside, and a federal government meteorological station and an experimental farm were in the immediate vicinity. The experimental farm raised no livestock, but was testing a number of different crops to find which were best suited for growing in northern climates. Ft. Simpson was an important, if small, community, being as it was the hub of transportation and communication to Canada's northern regions. The presence of an airport provided an extra bonus – mail was delivered every two weeks by scheduled air service.

The RCMP's facilities in the town were first class; at least that was what the couple had been led to believe. In actual fact, they offered far less utility than those in Arctic Red River. There were separate living quarters here for married personnel, but the building was 30 years old and in a sad state of repair. The balance of the detachment's buildings consisted of a single man's quarters, an office which housed a steel cage used as a jail, an ancient log house at the back of the lot, and a "warehouse," which in actuality was little more than a lean-to constructed from used lumber.

Completing the inventory were two outdoor biffies, one for the married member and his wife, and the other for the single man and any prisoners which may have been held from time to time.

Water for washing clothes had to be hauled up from the Liard River, while drinking water was obtained by melting ice stored in the bank of the slough which lay between the married man's quarters and garage. There was no electricity into the police facilities, but both Stan and Jean were used to such inconveniences.

A Jeep was at the post, a leftover courtesy of the US Army, but it was in about the same condition as the house, if not worse. The vehicle might be coaxed to run occasionally, but that was a risky proposition at best because the brakes did not function with any degree of reliability.

The first week in Ft. Simpson was spent getting acquainted with the people and absorbing the schedule of duties. A quick trip to Fort Wrigley was arranged for the purposes of meeting the inhabitants of that settlement. Vic Shattak, the game warden in Ft. Simpson at the time, escorted Stan in the RCMP scow. Jean went along for the ride, introducing herself around the little community while the men went about their business.

Shortly after they returned to Simpson, the first of the season's barges arrived. There was a load of building materials on board, and the manifest stated that it was consigned to the RCMP. The materials were hauled up to the detachment, but no one had a clue as to what they were for. Within the week, Insp. Larsen arrived with two other members to take inventory of the post.

Stan approached one of the two members, a staff sergeant, and asked, "Excuse me, Sir, but could you fill me in on what we're supposed to do with the lumber?"

"That's your new warehouse," the officer replied.

"Oh, I see," Stan said, still confused. "I guess we must have misplaced the paperwork. Do you happen to know when the carpenters will arrive to start the construction?"

"Carpenters?" the staff sergeant asked gruffly. "All the carpenters you're going to see are here already. Have a look in the mirror for one. And I suppose you can start about anytime you like," he added sarcastically.

Stan looked quickly at Joe Nelligan, the other constable stationed with him at Ft. Simpson, and hoped that perhaps Joe was less of a "wood butcher" than he was himself.

Although a game warden resided in Ft. Simpson, it was the RCMP which had the duty of issuing licenses and royalties, and inspecting and recording fur and hides taken. The recording of vital statistics was a constant agenda item for the Force in the North, and Stan's detachment had an impressive area to oversee. Their northern perimeter was marked by Ft. Wrigley. To the south their patrols ranged as far as the Trout River, where a fellow by the name of Jack Browning ran a viable farming operation. He raised beef cattle and operated a large garden, supplying fresh meat and vegetables to trading posts as far away as Aklavik until the last barges sailed. Their territory also extended up the Liard as far as the mouth of the South Nahanni River. Altogether, the Ft. Simpson post was responsible for almost 400 people in the surrounding lands.

Over the fall of 1950, Stan decided to rectify the situation of ground transportation. There was another Jeep at the RCMP detachment in Fort Providence which was in similar condition to that in Simpson. Both units were awaiting visits from the Condemning Board, an inspection unit detailed by the Officer Commanding of the sub-division. Assets could not be disposed of until such time that the board officially deemed them as scrap. Stan requested permission to have the Jeep at Ft. Providence sent by barge to Simpson, where he planned to marry the two junkers into a single

Stan's expertise in mechanics proved useful on several occasions. Two Willey's jeeps, each destined for the scrap yard, were combined into a single serviceable unit, handy for chauffering dignitaries, friends and neighbors.

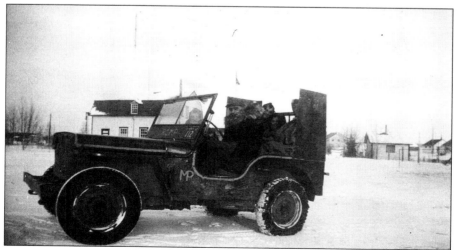

serviceable unit. He did not mind in the least being depended upon for transportation by others, but it was poor logistics for the police to have to beg a ride around town in a time of emergency. Besides which, the unit in Simpson was not scheduled for replacement until 1956!

The Royal Canadian Corps of Signalers had a decent inventory of spare parts, and Stan borrowed from their stock whenever he found that both units had a similar failure. The RCMP saw fit to supply new tires, and gradually the Jeep came together. By mid-winter he had a reliable, and safe, vehicle. The frame from the second Jeep was not wasted, either. Stan built a four wheel trailer with a stake rack box for hauling freight to and from the airport. Stan last saw his project, still running smoothly, 17 years later while working for Keir Air Transport in Hay River, NWT.

The North was an interesting place for visitors to come, and they could arrive by various means. Some made the trek by canoe, while others purchased fare aboard summer tugs or scheduled air service. Almost always they stopped in to see the RCMP detachment, and Stan had played host and guide to many, including high ranking church officials, politicians and adventurous tourists.

His least favorite of these were the politicians. One had arrived in Arctic Red River a few years back, and the man's hypocrisy had left Stan with a permanent distaste for people of his profession. He had insisted on meeting everyone in the settlement, shaking the hand of each and every citizen, kissing each and every baby, and complimenting all on their quaint but tidy homes. In the privacy of the RCMP compound, however, he sang a much different tune, condemning the "squalor" he had been forced to endure, and the filthy people he had to put up with in order to carry out the duties of his office. He rudely insisted that the constable provide a wash basin so that he could rid himself of their dirt left on his hands. Stan complied, barely able to contain his frustration for someone who could not see the beauty in the simple, honest lives these people were leading.

Within a few months of Stan's arrival in Ft. Simpson, he was notified of an impending visit by a federal Member of Parliament. The fellow's routine was much the same as that of the visitor in Arctic Red, except that this man insisted on drinking tea with everyone he met. By the end of the day, however, his taste shifted to whiskey, which he took straight from the bottle. All this came

after delivering numerous temperance lectures over a teacup earlier on.

In fairness, there was at least one politician whom the dubious policeman did hold in high esteem. Jean Lesage was the Minister of Northern Affairs, and cousin to the priest in Ft. Simpson. The only problem was that the cousins did not agree on many issues over which the minister had jurisdiction. While he would speak English to the residents and the unilingual constable, he would occasionally excuse himself to more exactly "explain" his position to the cleric in their mother tongue. Stan did not understand a word of what was being said in the back of the Jeep, but he found their animated conversations humorous all the same.

As had been his experience throughout the North, Stan found the people of Ft. Simpson to be most accommodating and peaceful. Crime was not, per se, an issue here. Whenever there was any suggestion of trouble brewing, the police had a standing offer to discuss the situation with either of the two Indian band chiefs in and around Simpson. The chiefs would carry the message to their people, and the issue was quickly dealt with by the populace themselves.

Stan always admired the Native peoples' honesty. He rarely, if ever, knew any of them to deliberately lie in an attempt to keep out of trouble. At the same time, he came to learn that it was best to ask quite specific questions; while answers were truthful, they might not always be complete. One incident involved the matter of the theft of a case of shotgun shells from a petrochemical exploration camp at Jean Marie River near Simpson. Stan made inquiries of the residents, wondering if any of them had any information about the stolen property. None had, so Cst. Byer next spoke with the chief. The chief asked whether the policeman had visited a particular individual, which he had.

"Where did you sit when you visited him?" the chief asked.

Stan thought the question a little odd, but replied, "There was an empty 50-pound milk keg on the tent floor. I sat on it while I interviewed him."

The chief smiled. "I think you were closer to the evidence than you know," he said.

Stan reflected on how the interview had gone along. What he had asked the man was whether he had taken the missing property. He also asked if he knew of anyone else who did. In both

instances the replies had been negative. As it turned out, these answers were true, firstly because the man had not stolen anything, but also because he did not know, for a *fact*, that his brother had. Now, if Stan had phrased the question as: "Are you in possession of shotgun shells which your brother told you to hide in a milk keg?" – well, there were only so many questions one could ask, after all. When Stan did visit the man a second time, and was prepared with the correct queries, the case was solved in short order.

The only real disappointment Stan felt about his new post was due to the fact that before his arrival the decision had been made to sell off the dog team. Teams were to be hired for any winter patrols where there was need to travel and aircraft were not available. There was only one occasion to hire dogs that first winter, and Stan did not make the trip. Joe Nelligan was detailed to the home of Jack Lafleur, a trapper who resided with his spouse and son at the mouth of the Nahanni River. Jack had a reputation among his neighbors for abusive behavior towards his common-law wife. Several times the woman announced her intention to leave, but whenever she did, Jack would wave an envelope at her and threaten to cut her out of his will. Jack had few possessions, but his wife had virtually none at all of her own. For years she remained an unwilling hostage for the sake of her son.

Jack had died suddenly, and Nelligan and a Special Constable were to investigate and take inventory of the estate. After Nelligan determined that the death was obviously from natural causes, Jack's wife presented him with the famous envelope, still sealed, and told the policemen that it contained the last will and testament of her deceased spouse. Cst. Nelligan opened the envelope and found that it contained nothing but a blank sheet of paper. Leaving the distraught woman and her son to consider their options, the two policemen went outside to prepare a place to bury the body of Jack Lafleur.

Not long afterwards, Jack's widow emerged from inside her cabin. She had a suggestion for the two men.

"Instead of thawing ground and digging a fresh grave," she said, "there's a hole just the right size you could use, and it's already dug out."

The three of them inspected the opening in the ground and, all things considered, judged it ideal for the purpose. So it came to be

that Jack Lafleur would spend eternity within the new hole he himself had dug earlier that fall – for a new outhouse.

The following spring, in Edmonton, Stan would testify that the boy, Alvin, was known to all as Jack's son. This was during a hearing held to determine if any of Jack's modest estate should be inherited by his family in the North. To that point in time, the Public Trustee had located a few blood relatives of the deceased. None had either seen or heard from Jack in perhaps 30 years, but all were prepared to divide his meager assets among themselves. As Jack had never legally married his spouse, the issue was one of interpreting the law as it related to common-law relationships at the time. In a decision which would never be rendered in today's more enlightened society, the judge declared that a common-law spouse in the Northwest Territories had ". . . no more rights than a common prostitute." A small amount was allocated to Alvin as blood kin, and the rest was split among relatives who had only the faintest, if any, knowledge of their benefactor.

The spring of 1951 brought tragedy to three prospectors on the Liard River near Ft. Simpson. All three hailed from Yellowknife, and were on their way to the Nahanni to seek their fortune. The leader of the party, Tony Gregson, knew the route well, or believed he did, and refused to accept the suggestion of hiring a guide. Three days after leaving Simpson, Gregson was found walking the southeast shore of the Liard. He was alone, and had nothing with him but the clothes he was wearing. He explained to the trapper who found him that he had lost his boat at the Beaver Dam Rapids on the Liard River. There was no sign of the two men, named Ginzilovich and Langell, who had begun the expedition with him.

When Gregson had last traveled through those rapids, the water had been higher, and had had no effect on his ability to navigate. In shallower water he had not been so fortunate. His boat's hull had been wracked on the rocks and, thoroughly unnerved by the unfamiliar waters, Gregson had somehow managed to propel his craft straight into a sheer three foot waterfall which swamped the boat and finished the job. Gregson stayed in Ft. Simpson for the better part of a week while Stan searched in vain for the bodies of the man's companions. A Territorial Air Services aircraft, chartered out of Ft. Smith, flew over the river, but had no better luck in finding the presumably drowned men. Gregson returned to Yellowknife in the meantime.

Another week went by before the badly decomposed body of one of the men was found on the shore of the river. There was little way by which to identify the man other than a distinctive belt buckle. Gregson was contacted and he identified the buckle as belonging to Ginzilovich. There were two cemeteries in Ft. Simpson, and Cst. Byer inquired whether Gregson knew Ginzilovich's faith. According to Gregson, the man had been Catholic, thus he was interred in the Roman Catholic burial grounds.

Because the identification had been less than certain, Stan had taken two precautions. The first was to remove and preserve the digits from the dead man's right hand, and to forward these to Regina for fingerprinting and possible identification. The second involved the method of burial. Beneath the coffin had been laid a couple of short poles, and between the poles were the ropes used to lower the coffin into the ground. The rope ends were left on top of the casket, and only about half the soil was replaced on top of it all.

Some weeks later, Cst. Byer received notice that Regina had identified the fingerprints as belonging to a man named Langell, who had once been arrested in Moose Jaw, Saskatchewan, for hopping freight trains. Stan contacted Gregson once more, who then told him that Langell had been Anglican. Langell's body was disinterred and transferred to the Anglican cemetery to rest in peace at last. The body of Ginzilovich never was recovered.

Tony Gregson would come to gain a certain notoriety within a few short years. Tony ended up working in a gold mine north of Yellowknife. At the end of a shift, he had been transported to Hay River on a charter flight flown by Max Ward, whose little company would one day grow to become a major player in Canada's aviation industry. As Tony disembarked from the single engine de Havilland Otter, his duffel bag made a loud thump on the dock.

"Whatcha got in there, anyway?" Max joked. "You stealing a ton of gold?"

"Not quite," Tony smiled back at the pilot, then he hoisted the bag over his shoulder and left for town.

Later in the day, when the mailbag that was on the plane was weighed, it was noted to be a few pounds lighter than it had been when Max had picked it up at the mine. The mine transported gold ingots by mail, and it was becoming apparent that Tony had devised a clever scheme. While the plane was being loaded, Tony

had managed to exchange a lead brick for the gold. Although the amount of lead he had slipped into the bag was shy of the weight of gold, the substitution had given him enough time to make his escape. He took a bus to Fort St. John, B.C., then made his way across the country exchanging tiny chunks of gold cut from the ingot for cash to live on. He was ultimately located in Australia, and after having enjoyed the good life for a few years, Tony spent three less comfortable years behind bars back in Canada.

Chapter 12

The winter of 1951-52 served a crushing blow to the claim of Simpson's moderate climate, and to the equally imaginative report citing the conditions of the living quarters. The Mackenzie had frozen-in early, preventing federal institutions in Ft. Simpson from taking receipt of their winter supply of heating oil. Once reserve stocks became depleted, Canadian Airways began flying in DC-3 freighter loads of the vital commodity. Charlie Hansen, a long time resident, ran the community's only delivery service, but he had left for medical treatment in Edmonton during the fall. His brother-in-law was to have taken over the duties, but he was suffering from depression after losing his mother and niece in a fire. That left Stan as the most qualified truck driver in the settlement, and he was called upon to work 24-hour long shifts delivering the drums from the airport into town. Once the oil shipments began, Stan's only opportunity to sleep was the half hour or so between his last delivery and the arrival of the next plane. It was an exhausting schedule.

Even with adequate fuel, it was virtually impossible to keep the married quarters the least bit warm. Jean had taken to wearing half inch thick, knee high duffels around the house, and the couple would visit the homes of other residents whenever an invitation was forthcoming. Extra care had to be taken when cooking, as any water falling on the floor would freeze before it could be mopped up. Returning home from Christmas Day spent with their good friends, John and Judy Gilbey, Stan and Jean could hardly believe their eyes. Despite the fact that they had left both their oil heater and the kitchen stove burning, a snowdrift had formed between

the window on the north face of the house and to within three feet of the heating stove on the opposite side of the living room. The situation was simply intolerable. (There was one particular method of keeping warm which the couple must have used, because Jean was three months pregnant as they celebrated their third wedding anniversary that New Year's Eve.)

At least there was lots to do, which helped take everyone's mind off the temperature. Jean had been hired to cook for some of the petrochemical crews which were heading into Ft. Simpson, and Stan was kept busy filling out mining claim forms. Oil exploration was so new to the NWT that there had not yet been a form designed to signify the area to which a given company had laid claim. Instead, a series of mining claims had to be completed, and these were designed to accommodate claims measured in the hundreds of square yards. The oil companies were staking out areas in the hundreds of square *miles*, which led to an enormous amount of paperwork. Much to the chagrin of the officers involved, the duty of completing those forms fell to the RCMP.

There was a rabies scare in Ft. Simpson that winter. Stan and Jean had brought with them to Ft. Simpson a blue collie named Laddie. When word broke about the rabies, they had had Laddie inoculated. Jim Ballentine, who had replaced Joe Nelligan as Stan's second, had traveled throughout the region vaccinating every dog he could locate. One evening Stan and Jean were returning home from a visit when they found Laddie was acting a little more boisterous than usual. He was whining and trying for even more sympathy than was his normal custom after being left alone. Upon closer inspection, Stan found that Laddie's lip had been bitten and was bleeding. The dog had obviously been in a scrap of some kind.

Jimmy Cree, a Scotsman and independent trader who ran a trading post in competition with the Bay, told Stan he had seen a wolf in his yard. This was very unusual behavior. Only one other time had Stan known a wolf to approach a human being. In Arctic Red River, a trapper had been chased by a wolf which nipped at his legs as the man mushed his dog team homeward. The trapper had died from rabies inflicted by those bites.

Fearing that an animal carrying the disease might be within the settlement, Stan set out two poisoned wolf baits, and warned the residents to keep their own dogs away from the baits. Two days later a dead wolf was found near Cree's home. The animal's head was removed and forwarded to Lethbridge, Alberta, where an

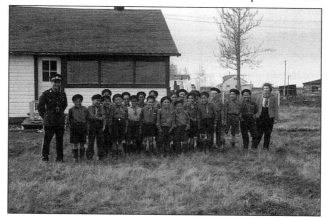

*Typical north-
ern Boy Scout
troop in 1948,
this one located
in Aklavik.*

examination confirmed the presence of rabies. Laddie never devel-
oped the disease, proving to any skeptics that the inoculations
worked.

January of 1952 saw the Commissioner of the RCMP, L. H.
Nicholson, launch a series of surprise inspections. One of the posts
he wanted to see was Simpson, and Cst. and Mrs. Byer could not
have planned it better. The commissioner was to sleep on the sofa
in the married quarters for the night, and it was 40 degrees below
zero. Comm. Nicholson was an avid scouter, and Stan arranged
for him to spend time that evening with the local troop, led by
Simpson's schoolteacher, Ted Blylor. After a very interesting visit,
the two of them returned home. Stan watched with some amuse-
ment later that evening as their guest would settle on the sofa for
a few minutes, then rise and walk over adjacent the oil heater
where he would position his rear end as close to the unit as
possible. He repeated the process several times before the night
was over. The following morning Jean asked him if he had found
the house too cold to sleep, but the commissioner was too gracious
to complain. He had rested quite well, he told her. Stan knew
better, but he also knew better than to contradict the officer.

Stan and the commissioner's pilot, Harry Heacock, put to work
in preparing the plane for its flight out of Ft. Simpson. Harry was
piloting a new model of the Norseman, and draining the oil was
no longer necessary. Instead, an oil dilution system had been
employed. A smaller reservoir, inside the plane's oil pan, could be
filled with a mixture of oil and gasoline. The diluted mixture would
flow upon startup, even in the coldest temperatures, although
warming up the engine in the morning was accomplished by

allowing the engine to slowly idle until the rest of the oil warmed as well.

Many pilots would keep their batteries inside shelter overnight, but Harry held a different view, believing that trying to get every last minute of life out of a battery was inviting trouble – inevitably it would fail when you could least afford it.

"I never bothered (taking the batteries out). What we did, we bought a new battery every year. I know Flying Services was always complaining. They thought a battery should last longer than that. We'd swing the prop in the winter, and never had any battery problems. Once you start using a battery, it warms itself."

The Norseman was designed such that it could be started in a variety of severe conditions. There was an electric starter off the batteries, a hand-cranked inertia starter could be used, or the engine could be fired by hand swinging the propeller when the other methods were not appropriate. Harry was an expert at hand swinging a propeller, and he did not want to expend the battery's charge. It could be a tricky process, however, and dangerous.

Harry explains, "You had to have someone inside the cockpit you could depend on to do exactly what you told him. You had to pull that propeller through until you found a cylinder that was on a compression stroke, and you'd count the strokes until you found it again. So it was 'Switches off!' and after you were on compression it was 'Prime!' while you pulled it through, and you'd get it on compression again and tell him to put the switches on. Then you pulled and jumped the hell out of the way, and it would start. Every time."

The commissioner thanked the couple for their hospitality and went on his way, never once mentioning the cold house.

For three months the constable and his expectant wife wondered how such an apparently considerate man could have overlooked their discomfort. Then, one day, the detachment's mail included a notice that a new facility would be built that summer. Comm. Nicholson had not forgotten them, after all.

When the materials arrived by barge that summer, it was an impressive sight. There was lumber not only for a new RCMP building, but for several other federal buildings as well. A large crew of Department of Public Works employees accompanied the shipment, and they immediately set to work surveying and otherwise preparing for the construction phase. Stan was more than a

little relieved that he and Jim were not expected to build this facility in their spare time. It would have been a far more difficult task than the simple warehouse he and Joe had built two summers previous. The plans called for a two storey duplex, which would house both the single and married men, and included a good sized office as well.

Early on into construction, Insp. Larsen stopped in again. Stan was telling him how pleased everyone was with the progress, when Larsen took him aside to explain how it all had come to be. It seemed that Comm. Nicholson had arrived unannounced in Larsen's office back in Ottawa that past January. Insp. Larsen stood and was fumbling with the buttons on his jacket when he was told to sit down and listen. The commissioner related to him the experience he had had in Ft. Simpson that one evening, and told the inspector in no uncertain terms that it was his intention never to be that cold again in his lifetime. He did not particularly care where Larsen found the money, but the detachment in Ft. Simpson was to be rebuilt that summer. And that was an order!

But Ft. Simpson was not the only detachment to be rebuilt. As Harry tells, "You see, for years the RCMP had lived in shacks in the North. It was the norm, the way of life. Now when Nicholson went through on this inspection, one of the first places we stopped was Fort Chipewyan. We stopped there overnight, and that old barn of a building they had in Chip had been there for years, and it had no insulation or anything. Harold Rutlidge was there, and his wife, Greta, was walking around in those big fur-lined socks like the aircrews used to wear, and a parka. So the next year they got a house. When Nicholson went around, he really shook up the living accommodation situation."

Other locations were similarly ill-equipped for hard winters.

"Some of these buildings would stop the wind, and that was about all," Stan recounts. "At Fort Norman, when Larry Hunter was there, they would put up a tent in the front room and they slept in that."

Harry adds, "If you ever talked to the old trappers up there, the old-timers, all they would ever talk about was the time they pretty near starved to death. Any time we're talking, it's about the time we nearly froze to death! My memories of all this is usually – well, in the winter time – it was just as cold as hell. After you stopped, you had to put the airplane away, which meant diluting and making sure it was tied down, which made you colder yet. Then

you'd head into the house where it was better, and Jean had the food on, and Stan had the fire going. And maybe a drink of rum or something like that. And I could sleep on any floor, any time."

Included among the building materials, there was even to be the added luxury of electricity supplied by a diesel light plant which would serve the Game Branch and doctor's residence in addition to the RCMP's unit. A boiler was installed in the basement of the duplex for hot water heating of the entire complex. Maintenance of all this new equipment would fall to the RCMP personnel stationed there, but that was a small price to pay for the comfort which it all promised.

The game warden's facilities were completed in early summer, and Stan and Jean were to move into these accommodations temporarily while the police building was finished. In the midst of moving personal effects and furniture into their temporary home, word was received for Stan to begin a search up the Nahanni River for a trapper who had left Simpson two years earlier, but who had not since returned. Stan requested that the search be postponed until after Jean had given birth and returned to health. The postponement was granted, and on the afternoon of July 7th, 1952, Jean delivered their son.

Being God-fearing people, the couple advised the parish priest of the birth, and asked that he come to the hospital to bless the baby. There was a meeting of numerous Catholic Church dignitaries in Ft. Simpson that week, so the priest offered to go the request one better. Young Douglas Stanley was baptized by a bishop, then blessed by two others and no fewer than seven priests! (In later years, Stan would come to wonder whether all that had done the kid any good.)

Four days later, with Jean and the baby both doing well, Stan began the trip to look for Albert Faille. Accompanied by a pair of game wardens, Malcolm McNab and Lou Reese, and their guide, Moises Antoine, he set out in a 28-foot scow borrowed from the Department of Agriculture. Powered by twin 40 horsepower Universal inboard engines, the craft would serve them well in negotiating the treacherous waters of the Nahanni. In tow was a canoe to be utilized as standby transportation.

Owing to their late start, the party moored below the Beaver Dam Rapids on the Liard. Stan did not want to attempt to navigate the rapids while he was in a fatigued state, so he nosed the boat into shore and the four men made camp. They were to set out early

on in the new day, so no time was wasted in erecting their finely meshed mosquito bars and crawling into their sleeping bags for a full night's rest. Stan had tied his mosquito bar to a tree stump, and he was just starting to drift off when he noticed that a few wasps had somehow gotten inside the barrier. He shooed the intruders outside, refitted the netting under his sleeping bag, and settled in once more. Again he was awakened by the buzzing of wasps, and this time he decided to investigate. He quickly discovered that in his haste to get to bed, he had been somewhat careless in choosing his site. The stump he had tied to was home to several hundred wasps, and the stump was inside his mosquito bar. Managing to somehow remain free from stings, Stan moved his bedroll a few yards away and bedded down for the night.

The rapids were in fine form the following morning, and as if to complicate matters, one of the boat's engines began to act up. The boat made it through, owing in large part to the particularly colorful language the four men used to coax the craft along. Once safely past the rough water, Stan idled the boat into shore to inspect for the cause of the engine's hesitation. The distributor cap was loose, and the electrical hardware within was flopping around, robbing the spark from that engine. Repairs were quickly made, and they carried on to the mouth of the Nahanni, where they picked up a fifth member, Gus Krause, who was familiar with the river as well.

Gus requested that the others help him with a mission prior to commencing the search for Albert. He had been asked to repair an Indian burial stand, which had given way to the elements of Nature. One of the vertical supports had broken away from the rest

The remains of the coffin's occupant were returned to their final resting place.

The Nahanni's rugged beauty is equal to that anywhere in North America.

of the structure, and the coffin's occupant had been spilled to the ground. After locating the site, the men replaced the remains into the casket and erected the pole back into place, returning the body and its container high off the forest floor to keep it away from scavenging animals. The task completed, the men paid their final respects and re-boarded their boat.

The Nahanni is a fast flowing river, dropping several hundred feet in elevation over its run. Navigating upriver promised to be a considerable challenge, even with the power their boat had driving it. They entered into the lower canyon, Dead Man's Valley, through a six mile long piece of water called The Splits. This was an area where dozens of smaller streams converged, intertwining with one another amid an equal number of gravel bars. The channel changed constantly as the streams carved new routes through the gravel, and the party was forced to be ever vigilant in selecting which of the courses to run. The serpentine passage made the six miles much farther than that, and their progress was slow. Towards the end of the canyon the water became a single band, but that was comprised almost entirely of rapids, with few calm areas in which to shelter. At the end of the rapids stood a lake, its placid waters a stark contrast to those which preceded it. They carried on to where the Flat River enters the Nahanni, and stopped in a peaceful bay for the night.

The trip was taking an inordinate amount of time and was very demanding, both psychologically and physically. At several locations the men had been forced to pole their way through the torrent, and all were grateful for an opportunity to finally rest. Here they cleaned up and pondered the relatively short distance they

had managed on the first day. What they needed more than anything else at that point was a plan, and each man had his say in how to proceed next.

Early the following day Stan noticed Gus gazing purposefully up the Flat, and he joined him for a look.

"What's going on?" Stan asked.

Gus pointed upriver.

"There's a clearing up there," Gus answered. "I think I can see smoke from a fire."

Stan could make out a wisp of smoke along the shoreline, and together he and Gus boarded their canoe in order to investigate. As they approached the clearing they saw Albert Faille, sitting on the back of his own boat, and peacefully smoking a pipe as he watched his visitors' camp. Introductions were made, and Albert inquired as to the purpose of their journey.

"We were looking for you," Stan explained.

"Guess you found me, then," Albert smiled. "I was wondering what the five of you might be up to. I saw you setting up camp yesterday. I'm just on my way back to Simpson anyways, so I suppose there's no harm if we all go back together. If that'd be OK with you men, that is."

A meeting was hastily called among the members of the search party to decide on their next course of action. Finding Albert had not taken so long, after all, and Virginia Falls was a short distance away. Having a sheer drop of over 300 feet, twice as high as the more famous Niagara Falls, Virginia Falls was a marvel of Nature rivaling any in the world. Deciding it might be years, if ever, before an opportunity to see the Falls might present itself again, they asked if Albert would join them on a slight diversion.

"We've got lots of supplies," Stan said to Albert. "Would you consider guiding us up to Virginia Falls for a short trip? Unless of course you're in a hurry to get back to Simpson."

Faille happily accepted their invitation.

"I ain't never in a hurry," he said, and after the search party stowed their non-essential equipment at their Flat River camp, all commenced the impromptu sight-seeing excursion.

While the majesty of Nature inspired awe from the men as they wended their way, it was a good thing that Stan's company included so experienced a group. Operating a flat bottomed boat in

*Cathedral Rock, also known as
The Bishop's Palace.*

fast water was tricky enough, but Hell's Gate was a test beyond mere competence. Hell's Gate consisted of a 90 degree elbow in the Nahanni River, with sheer granite cliff walls surrounding all, leaving no avenue of escape should things go awry. The river came crashing down from the ell to their right, straight into the rock at the opposite side, sending froth and spray high into the air above them. To get through the intersection of the ells without being smashed against the rock face took all of Albert's and Gus' knowledge, and all of Stan's courage. But it was done. Safely past, and keeping to the river's edge, they slowly traversed further upstream until they were at the base of the falls. Two glorious days were spent camped in the wilds there – hiking, exploring and taking pictures – before they reluctantly decided that the brief holiday was over. Stan had a family to attend to, after all.

Distances which had taken hours to travel into the river's flow took mere minutes with the current at their backs. This fact posed its own set of problems, and being crushed like bugs back at Hell's Gate seemed to Stan to be a distinct possibility. Once more Albert and Gus intervened with the laws of gravity and momentum, and they sailed without incident past Cathedral Rock, a granite monolith which stretched hundreds of feet skyward at the entrance to the Gate. With the worst behind them, the rest of the trip was left in the hands of Albert while the other five relaxed and watched the scenery drift by. Just above the Flat River, however, Stan had an odd feeling of impending doom, and he sat up and began to take more notice of their surroundings. He was startled by the sight of a gravel bar dead ahead of them.

"Albert!" he shouted, pointing beyond the bow of the boat. "Look out!" But it was too late. The water carried them into the rocks, which smashed a yawning gap in the bottom of their scow.

They were in no immediate danger, and after fastening ropes to the damaged boat, the men got to shore using the small canoe. From there they pulled the disabled unit, which now rested against the river bottom and was half-filled with a ton of water, closer toward the river bank. It was another quarter of a mile to calmer water, and the men were forced to heave and tug and otherwise manhandle the stricken craft to a place where a closer inspection could be made. At this point it seemed hopeless, but the vast knowledge and experience of Stan's companions came to their rescue.

The first order of business was to get the grounded boat as close to shore as possible. To do this, Albert constructed a device called a Spanish winch. A line was secured to the shore, then wrapped once around a long, sturdy pole placed on end about half way between that fixed point and the boat. The opposite end of the line was attached to the boat itself. A shorter pole, perhaps eight feet long, was hooked into the rope where it wrapped around the larger pole, and the men took turns walking the contraption around. As the pole was turned on its axis, the line coiled around it, drawing the boat nearer. This procedure was repeated several times, fore and aft, with a six inch gain being hailed as a major victory. At length the boat was ashore, but it had to be purged of the water which now filled it nearly to the gunwales. It had taken them almost two full days to get to this point in the process.

The only way to navigate beyond the Falls is a portage of over a mile, most of which is straight up.

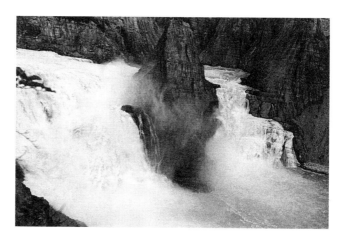

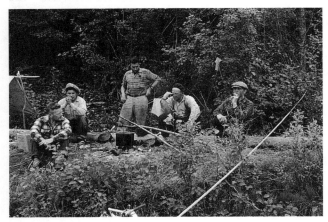

An exhausted party rests before the final leg back to Fort Simpson. Left to right: Gus Krause, Moises Antoine, Malcolm McNab, Lou Reese and Albert Faille.

The men had found the remnants of a long abandoned camp, and Albert took a number of six inch wide boards, some canvas and a short pole and proceeded to construct a crude, but effective, sump pump. Stan had some work to do as well. The inboard motors had been flooded, and would never run again in their present state. Stan and Lou carefully removed the oil, taking care to separate it from the water which had infiltrated the oil reservoir. Next, Stan tore the engines down piece by piece, drying each item before removing the next, and then reassembling the works. Spare oil was added to that which they had salvaged in order to make up enough to refill the reservoir. Thankfully, they had not lost any gasoline, and before long the engines were purring nicely.

More boards were located to be used to patch the hole in the boat's hull, and after a four day delay, the group

Before heading back to Fort Simpson, Albert gets his first haircut in over two years. Moises had many talents besides being an accomplished boatman.

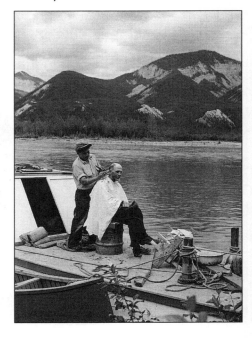

started out again for Ft. Simpson. With their scow in a precarious state of repair, the travelers took a great deal of care in choosing which course to follow. Water seeped into where they had patched the hole, and it was a full time job baling it out. They did not want to take any unnecessary risks in the rough water, and often they would pull into shore so that Albert and Gus could walk downstream to get an advance look at what lay ahead. A map would be drawn and discussed before resuming the trek. All these precautions made for slow going, but helped ensure they would get back safely. Once they arrived at the junction of the Nahanni and the Liard Rivers, and the patch became better sealed by the silt carried in the Liard's waters, the tempo of the trip increased noticeably.

The party camped at the junction for one night, with Stan visiting the few people who lived in the immediate vicinity. Gus stayed behind the following morning as the rest of the group headed to Ft. Simpson. Tired, but otherwise healthy, they arrived there before noon, 30 days after beginning the search for a man who had not been aware he was "lost" in the first place.

A trapper turned prospector, Albert had been searching for the legendary McLeod mine. Years earlier, a pair of brothers named McLeod had reputedly discovered a rich vein of gold somewhere along the Nahanni. The remains of the men had been found in Dead Man's Valley. Along with their skulls and a few other bones, a note which provided a hint of their find was all that was needed to foster the almost desperate belief within numerous prospectors that a motherlode was just waiting to be found once more. And none was more determined

Looking back down river from the top of the Falls. This view provides a clearer perspective of the magnitude of the climb Albert Faille had to make on his many trips up the Nahanni.

to locate the mine than Albert Faille.

Over his lifetime, Albert made no fewer than a dozen trips up the treacherous waterway, each one a journey of over 400 miles. The half way mark was Virginia Falls, at which point Albert carried, board by board, the materials to construct a new skiff to continue upriver beyond the falls, as well as the outboard and all the supplies required for that season's search. The portage was over a mile in length, much of which was almost straight up, and it took the aging man a full week to accomplish this back-breaking endeavor.

Albert never did find the gold, but his dogged determination made him a Canadian folk legend.

Chapter 13

By the fall of that year, the new police building was finished. In the basement was a 2500 gallon cistern which held water pumped up from the river. The silt would settle out after a few days, and the water could be used to wash clothes in the new electric washing machine or for hot showers. Drinking water was still obtained by melting ice, but these accommodations were simply marvelous compared to any that either Jean or Stan had known in the North. That November, Stan was promoted to the rank of corporal, and life was wonderful. The couple signed on for a second three-year tour of duty in the community of Ft. Simp-

The new quarters, ordered by Comm. Nicholson after experiencing a very chilly visit in the winter of 1951-52. The new building contained many "luxuries" such as running water and electric power, as well as a first rate furnace.

son, which would be Stan's last in the North as a Mounted Police-man.

The winter of 1952-53 provided Stan's last opportunity to make a patrol by dog team. The Game Warden, Malcolm McNab, was to travel to Jean Marie River near the Horn Mountains, following a trap line and taking a census of furs trapped that winter. A team was rented, and Stan accompanied Malcolm for the journey. On the way back, the corporal decided to test himself to see whether he still "had it," running the final 10 miles into Simpson on snow-shoes. He still had it alright, but he "felt it" for several days afterwards.

Come Christmas, the RCMP would attempt to provide a little cheer to its members in more remote locales. Whenever one of the Force's aircraft made a stop at a detachment, left behind would be a hamper, filled to overflowing with nuts, fruits and candies. Harry Heacock dropped off the treats earmarked for Simpson and, as was his custom, Stan bummed a ride to the next stop. He and Harry flew to Ft. Norman and delivered the hamper, stopping to chat with the men stationed there. When it was time to leave, Harry decided that it was too cold to use the starter; he did not want to risk draining the batteries. Believing that their stop would be shorter than it actually had taken, Harry had not used the diluter, and the oil was stiff enough that hand throwing the prop wasn't an alternative either. Stan was summoned to man the inertia starter.

This method involved inserting a handle into a slot at the side of the engine's cowl, and manually cranking a shaft which was connected to the starter by a series of gears and a flywheel. It was not an easy chore, especially when the engine was cold.

"I suppose we were just in too long," Stan notes. "By the time we were to leave, the engine was pretty stiff. I'd crank the inertia starter up to about 4000 rpm, and Harry would throw the switch. Of course nothing happened the first few tries, until the engine loosened up a bit. Once he engaged the main starter, the inertia starter would slow right down, and I'd have to crank like crazy to get the speed up again."

Harry is less generous regarding the utility of this particular method of starting the engine.

"It was really a Rube Goldberg affair," he sniffs. Before turning the crank, you had to lift the brushes off the starter motor by

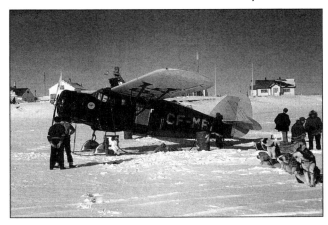

The origins of "self-serve," fueling the RCMP Norseman, CF-MPF. The aviation gasoline was pumped by hand from 45-gallon drums.

engaging a device appropriately named the brush lifter, which was ". . . right handy there, beside the crank handle. And usually the brush lifter wouldn't work, so we'd end up swinging her by hand anyway. You'd do that on snow. Of course you couldn't do it on water, you had nowhere to stand. Then you had a solenoid that closed the clutch down, and gives the engine enough turns that it would run – if you were lucky. And you'd be surprised how much sweat you could work up even on a cold day."

"By the time the engine fired, I could hardly hold my arms above my waist," Stan confirms. "I guess you could say I paid for that particular 'free' ride."

Cold weather not only made starting the aircraft difficult, it could also lead to expensive maintenance and repairs. Harry notes that, "They were very expensive to operate, the old fabric airplanes. We were in Cambridge Bay one night, and it was very cold, I would think about 60 below. I was thinking that if it's no wind, I would rather go out and refuel when it's this cold than wait until the wind comes up. It might be only 30 below, but it's easier fueling without the wind.

"So there we were, out in the starlight and 60 below. We carried a hand pump and a hose. The hose, to get it into the storage compartment on the airplane, was wound up. So we got outside, and that thing was hard to unwind, it was more like a spring than a hose. We got one end on the pump, and I was up on the airplane with my parka all pulled up and getting the gas into the funnel when somebody said something, and I turned and said 'What?' and a little bit of the gas came out and spilled down the side of the plane. That whole area of fabric just spider-webbed. The gas was

so cold, well, it basically just wrecked the fabric. We had to come Outside and get it all fixed up and repainted."

The following spring, Simpson was treated to a royal visit by Prince Philip, the Duke of Edinburgh, husband to Elizabeth II, Queen of England. Stan received ample notice of the visit, and three days were spent working out the fine details. On the morning the Duke's plane was due to arrive, Stan received a wireless message that he was to supervise the brewing of an urn of coffee, which was to be placed aboard the aircraft for its return flight when it landed in Simpson. The airport manager's wife, Annie Hunley, was rightfully proud of her reputation as an expert in the culinary arts, but Stan could not pass up an opportunity for some fun. As the woman protested vehemently, Cpl. Byer provided her with precise, step by step instructions on how to make the coffee. It never occurred to her that Stan's presence was required for security reasons alone, and he was not about to share that little secret with her just yet.

When Prince Philip arrived, Stan, in full dress red serge, had an opportunity to meet and shake hands with the royal. Jean, too, was granted that honor, then the Duke proceeded to mingle among all who had made the 10 mile jaunt to the airport. Everyone in the community was elated at being given the opportunity to see a member of the Royal Family, and the gracious prince did not disappoint any of them. When Annie eventually found out about the trick Stan had played on her, she didn't know whether to be angry with him or to simply share in the humor of the moment. Stan kept his distance from her for a few days, just to be safe.

Much of Stan's time was spent more in community service than in what might be considered more typical police work. His expertise in repairing engines was made available on several occasions. Art Trace, Stan's Constable from spring of 1955 to May of 1956, recalls, "That's the thing that stands out in my mind more than anything else about Stan. He was always tearing down an engine of some sort. The jeep, the lightplant or whatever. It seemed like everyone in the settlement would bring something over at one time or another."

He made time to rebuild the mission's tractor, and both the truck and light plant owned by Indian Affairs. When not up to his elbows in grease, Stan might be found with the Hudson's Bay store manager, Jack Craig, running the movie projector on Saturday evenings. Being a member of the RCMP meant being available to the

community, but this was something Stan relished in spite of any implied obligation.

In fact, any community-related activity was seen as an opportunity to pitch in by just about everybody living in Ft. Simpson. Andy Wittington, who owned a small store and the town's only hotel and restaurant, had built a hall which was used for dances or other social gatherings, and there was never a charge for attending whatever festivities had been arranged. As well, Andy saw to it that anyone genuinely in need of credit had access to the goods they required. Whenever he departed the settlement for business or vacation, he left with whomever was "minding the store" a list of those families for whom payment was not an issue. Because he recognized the needs of his clientele and was never known to cheat anyone in any transaction, that same courtesy was extended to him in return.

Charlie Hansen, a Danish jack-of-all-trades who arrived in Simpson at about the same time as Andy back in the 1920s, was a first rate carpenter. Anything Charlie built was done so with a craftsman's care. As well, Charlie was a cook and a handyman, and he ran a modest mill which produced rough lumber. In addition to this impressive list of occupations, he ploughed the roads during the winter months. Often Charlie would barter his skills in exchange for other services or goods when cash was not abundant.

Jack Craig's wife donated her spare time to a local chapter of the Girl Guides. The fellows from the Signal Corps organized softball and hockey teams, and constructed the outdoor rink every winter. The list was endless; every person living in Ft. Simpson contributed in one fashion or another.

This community spirit was best exemplified when Andy Wittington announced that he was about to sell his interests and move on. It was not known whether the people would still have access to the hall once Andy had left, so it was decided to construct a new one. A committee was formed to organize the project. The Department of Northern Affairs was petitioned to reserve land for the building, and everyone on the committee was active in selling shares to raise money to cover whatever costs were incurred. Jack Browning, who operated a mill at his farm site upriver, provided the lumber at no profit. Practically everyone picked up a hammer at some stage, with Charlie Hansen doing the finishing work.

Benches were built, while other furniture was donated by the Hudson's Bay store, the Signal Corps and the mission. In the end

they had a 1000 square foot hall which served Ft. Simpson for several years to come. A little extra sense of community was derived from the fact that virtually every person who made use of the facility had had a hand in its origin.

It was not mandatory that the RCMP meet every aircraft which arrived in Ft. Simpson, but Stan made a practice of doing just that. More often than not the pilot needed a ride into town, and Stan was happy to provide the service. It gave him the chance to talk about planes, flying and whatever else was required to butter up the pilot enough to permit the corporal a courtesy flight. In this manner, Stan kept himself familiar with operating a plane, even if he could not officially log the hours.

One afternoon Mike Krutko landed in Ft. Simpson. Mike had purchased a four place Stinson in Edmonton, and was on the return journey to Ft. McPherson. After spending the night, Mike topped up his fuel tanks and took off. Something went wrong, however, and he had to make an emergency 180 degree turn back to the Ft. Simpson airstrip. The plane landed very hard at the end of the runway, damaging the undercarriage and wings, but Mike was unhurt in the incident. Stan learned a new saying that day, which is used extensively among those in the world of aviation. That is, any landing you can walk away from is a good landing.

Another time, a Wardair Otter was making use of the RCMP's floating dock. Stan and the pilot were visiting in the police office when a man entered.

"Your plane's sinking," he said matter-of-factly.

This particular fellow had a reputation for being a practical joker, so neither of the other two paid his announcement any mind. After a few minutes, the man returned.

"Don't you care about your plane?" he asked the pilot. He insisted that they had better get going, or the plane would be lost.

There was something in his voice which made Stan think that they had better have a look, and sure enough, when they got to the river they found that the plane's right float was well under water, and the wing tip was just brushing the surface. Stan yelled for the pilot to get a couple of mattresses from the prisoner's facility, and ran for the police scow. Placing the mattresses at the bow, he maneuvered the boat such that the plane's tail rested on them. The pilot cut the Otter loose from the dock and Stan used the boat as a

barge to push the plane onto shore. The pair of them managed to swing the plane around and heel it into the riverbank, tail first.

When they inspected the float, they found a jagged tear in its side, below the water line. Stan had a look at the dock to see what had caused the damage. A bolt had loosened, and its square edge had cut a rip into the float as the plane rocked against the dock with the motion of the waves. Stan felt a real sense of responsibility for the near disaster, having assembled the dock himself that spring. The pilot was far more forgiving, however, and was just happy that they had caught the incident in time.

By mid-September of 1953, Stan and Jean left Ft. Simpson for a two month holiday in Edmonton. The downside to this long over-due vacation was that they would have to return Laddie to his original owner. For three years, the collie had been very much Jean's dog, lying at her bedside until she was safely asleep, and following her everywhere during the day. The new baby changed the couple's priorities, and Laddie was fiercely jealous of the attention being paid to the most recent addition to the Byer household.

"Laddie was very protective of you," Jean recalls. "He would lie just beyond reach of the playpen out in the yard, and no one could get near you. If either of us showed our face, however, Laddie would run off. It was like he didn't want us to know."

Under no circumstances would he permit young Douglas to touch him. Stan and Jean were wondering how to deal with this, when they received a letter from the woman who had last owned the dog.

The very day before leaving for this post, Stan had been assigned to investigate a door to door photographer in the Edmonton area. The man was making his rounds in Calder, just north of the city, and his scam involved taking portrait pictures, and then collecting a large portion of the fee. He would simply "forget" to return with the photographs, and the complaints were now starting to arrive on a daily basis. Stan was interviewing some of those who had fallen prey to the fraud, and as he walked into one particular side yard, he was surprised by a large collie which jumped up onto his chest. He began playing with the dog, and Laddie was soon wagging his tail and ready for more. The collie's owner made her appearance then, and was nothing short of amazed at the sight. She explained that the previous day, Laddie had broken his chain and bitten an Edmonton city policeman who had entered the yard.

Laddie was under a death sentence for the offense. When Stan offered to spare the dog by taking him north the next day, the woman accepted the arrangement without hesitating.

The letter inquired whether they might now part with the animal so that he could be used for breeding purposes. Laddie was one of only a very few blue collies in western Canada at that time. It was again the perfect solution to a problem involving a dog which was perhaps just a bit too fussy about the company he kept.

Later that same season, Stan was faced with one of the most dangerous situations of his career. Chief Joseph Norwegian called at the office one evening to report that things were getting out of hand down in the river flats. A number of people had set up camp there for the summer, and one of them, Henry Squirrel, was threatening some of the others with a rifle. Stan drove the RCMP jeep down to the flats and to within a few yards of Henry. He knew the man reasonably well, and believed Henry would surrender the weapon without any fuss.

He approached the man slowly and extended his hand out to him.

"Come on now, Henry," he began, "let's have the rifle before you get into any real trouble here."

As Henry turned to face the policeman, he had the gun pointing down and away from him at his right side. Suddenly the rifle discharged, and the bullet struck the earth between Stan's feet. The corporal was unsure whether Henry had meant to fire, but he gave the man no opportunity to chamber a fresh round if that had in fact been his purpose. He lunged at Henry, putting him to the ground and disarming the startled man at the same time.

As there was a question as to Henry's intent, the Justice of the Peace recommended that a charge of discharging a firearm within the settlement limits was the most appropriate conviction. Henry was found guilty and served three months in Ft. Simpson's RCMP jail cell.

Stan was perfecting a habit of running into people who would later make a name for themselves. Thirty years later, Henry won a lottery prize of a half million dollars and took up residence in Edmonton. Within a year and a half, his good luck continued, and he won another 50 000 dollars in a lottery. Like so many others who cannot handle their new-found wealth, Henry too was unable to retain any of his winnings. He found many new "friends" who

lasted only as long as the party did. Henry died in the late 1980s, owning little more than he had most of his life.

Stan and Jean's home was becoming more and more comfortable. In the summer of 1954, a well was dug adjacent their duplex. There would be no more melted ice for drinking and cooking, and no more silty water for washing. Fresh, clean water was available in abundance. Stan had the community's resident physician send a water sample away for analysis before the final connections were made. The tests confirmed the water's purity, and also determined that its natural fluoride content was precisely in line with what was being suggested for supplementation of potable water in urban centres.

Cpl. Byer received something of an education in "the system" that summer. A drinking party across the river from Ft. Simpson had gotten out of hand, and Stan had to make a couple of arrests. One of the men taken into custody was the Indian Agent's assistant. He had attempted to ram Stan's boat as the policeman initially approached the party, but offered no other resistance. At the time of his hearing, the man insisted on having an interpreter present, which was his right. The reason the man knew of that particular right was that one of his official duties as assistant to the Indian Agent was to act as his interpreter. He had served in that capacity on several occasions, and was quite content to delay his own hearing for a number of days while another suitable individual was located.

Stan was curious as to why the man believed he needed someone to translate for him at the trial. He told the corporal that he didn't really need one but, as he was entitled to one, why not give someone else an opportunity to earn a little money at the Crown's expense? Stan, being a very practical person, failed to see the logic of it all, but he did learn something about exploitation in the course of the discussion.

Back in basic training, Stan and many other recruits would question why so many things were often practiced to the extremes that they were. A demonstration in self defense would include a particular tactic. The tactic would be repeated every day until it became routine. After many weeks, the routine would become reflex, yet still they would practice. Reflex permits one to act without having to think about what it is one must do, and from practiced reflex evolves instinct. It is instinct that can save your life, and Stan was about to learn to appreciate the purpose of those

lessons learned so long ago, as well as the apparent value of his life itself.

Returning home from a late game of crib with friends in the Signal Corps, Stan heard a sound coming from the tall grass which lined the path he was walking. It was a short hissing sound, *psst*, as though someone was trying to get his attention. Unable to see anyone, he parted the grass for a better look, and as he did so a man lunged from the cover, cursing. Stan's peripheral vision caught a glint in the moonlight, and instinctive reflex took over, fueled by a rush of adrenaline. More than any other weapon, Stan feared a knife and the havoc it could wreak. Unaware that he had even done it, he blocked the attacker's arm, wrenched the knife away and threw the man solidly to the ground in one motion. A very surprised look was upon Leo Norwegian's face as he was hoisted roughly to his feet and led unceremoniously to the holding cells where he awaited trial. In this instance, there could be no mistaking his assailant's intent. Or so Stan believed.

A week passed before a magistrate and crown prosecutor could make the journey from Yellowknife. Prior to the trial, a charge had to be decided. As Stan had not been in uniform at the time of the attack, the judge felt they could not lay a charge of assaulting a peace officer. Absurdly, attempted murder was not given consideration because no injury had been inflicted. A host of other equally serious offenses were bypassed for obscure reasons. The accused was, after all, Leo Norwegian, the chief's son. Finally, it was decided that a charge of "intent to commit an indictable offense (unspecified)" would be suitable.

Leo pled guilty to the charge. Stan was asked to provide his account of what had happened that night, after which Leo was given an opportunity to speak. For the first time since his arrest, he explained what had compelled him to draw a knife against an unarmed man. In hushed tones, he told the court that he believed his brother had been making advances on his wife, and he wanted to teach his sibling a lesson. In the heat of anger, he had innocently mistaken the corporal for his brother in the restricted light.

The magistrate listened solemnly, and at the conclusion of Leo's testimony he pronounced his findings, impressing all in attendance with a dissertation on just how serious a matter this was. It was just good fortune that the man Leo attacked was able to defend himself, he said. As the judge continued, Stan wondered silently how the good fortune could be seen as having been Leo's. If the

intended victim had in fact been Leo's brother, the judge ranted, the accused might now be appearing in the court on a charge of murder. For a quarter of an hour, he went to great pains to spell out how dire the consequences might have been, and at last he announced that an example must be set. Leo Norwegian was sentenced to six months probation, and ordered to pay a 30 dollar fine. His business done, the judge left the court.

Stan was literally in shock. He went back to the detachment office and tried in vain to file some papers, placing them away, then retrieving them from the drawer again, over and over. The crown prosecutor sat wordlessly, watching as the corporal wandered aimlessly around the office. Finally Stan turned to him.

"Is my life really only worth 30 dollars?" he demanded.

"I don't have an answer that would make any sense," the man replied. "But I will say," he went on, "that in all my many years of practice, I have never before seen anything which so closely meets the definition of a miscarriage of justice."

He then reached into his valise and withdrew a large bottle of whiskey.

"Let's get drunk," he suggested. A few hours and 26 ounces later both he and the policeman had thoroughly accomplished that mission.

Chapter 14

On that occasion at least, Stan, or anyone in a similar position, might be forgiven for overindulging in drink. The sad truth is that alcoholism is a plague which seems to infest more remote communities to a greater degree than is the case in urban centres, or perhaps it is just more visible among a smaller population. But Stan had had a brush with making the practice a routine back in Manitoba. Whether it was due to a lack of other means of entertainment, or more simply an easy vice to acquire, Stan had inadvertently aligned himself with a group which leaned more to drinking than to less harmful diversions.

While in The Pas, Stan was asked to assist the Liquor Board in investigating an unusual amount of breakage reported by that community's liquor outlet. To receive compensation for broken containers, the claim had to include an intact liquor seal. It was common for the employees to break a bottle off at the neck, preserving the seal, and then to filter the liquid through a series of fine cloth mesh layers to remove any minute particles of glass. Thus the party was always well stocked with spirits, courtesy of the Manitoba government. Stan was beginning to recognize that chronic drinkers would go to extreme lengths to support their needs. While he was far from becoming an advocate for prohibition, the constable began to understand that drinking should have a far less prominent place in his life, before he too began any desperate behavior. He was fortunate enough to have the strength to kick the habit before it took a stronger hold of him.

More often than not, whatever trouble arose in Simpson was the result of alcohol abuse. Both transient and permanent residents were guilty of overindulgence upon occasion, but thankfully not all incidents were so serious as to place lives in jeopardy. One summer evening, Stan received a call complaining of a noisy party down by the river. He jumped into the police Jeep and went off to sort out the problem. When he arrived at the offender's river boat, however, all was peaceful. Stan called to the owner, who appeared on deck and claimed no knowledge of a noisy party. Satisfied that either the call was a waste of time or the party had simply ended, the corporal turned to leave. In the near dark, Stan had to pick his way carefully among the boulders which rested along the river-bank. Even in the poor light, though, one of the boulders appeared to be out of place, and the intrepid policeman stopped to investigate. What he found was a young woman, her dress hiked up over her head, crouched down and attempting to hide among the rocks.

He helped her replace her dress to its proper position, and then he escorted her home. It had never before occurred to him that a pair of buttocks could be used as camouflage in just the right circumstances, but he added this newly discovered fact to his list of investigative tools. In the rearview mirror, Stan could see the owner of the river boat watching as he and the woman drove away. The man did not look as though he was much impressed with Stan's keen powers of observation and attention to detail.

On another occasion, one of the chiefs requested Stan's assistance in toning down a drinking party which was getting out of hand. A more "official" request was in order, it seemed. Stan arrived with the chief, and the occupants of the house politely sat and attempted to appear sober. It was obvious they were not, but Stan could not locate the supply of liquor. As he was about to leave, he noticed that an area carpet seemed somewhat askew. He lifted the corner, and found a trap door beneath which was a small storage area. Inside was the jug of home brew which was responsible for the trouble. Stan emptied the container outside onto the ground, and he and the chief went their way without further mention of the transgression.

There were many opportunities to amuse oneself on those occasions when the work was caught up and no patrols were scheduled. One of Stan's favorite pastimes was watching ravens at play. Looking west from the kitchen window, he could see the bell tower of the Catholic mission. There was a cross atop the tower, and

ravens would gather on the mission roof for soaring competitions. One by one each took a turn perching itself, wings spread, on top of the cross. When just the right breeze would come along, the bird would free fall and glide as far as the current would carry it. At the moment the raven had to flap its wings in order to remain aloft, it would peel off and take a place at the end of the line on the roof. They would keep this up for as long as they were not disturbed, or until they simply tired of the game.

Stan often marveled at the intelligence of these birds. In Arctic Red River, the two policemen would start putting out scraps of stale bread in the spring, once the ravens had returned from wherever it was that they spent their winters. Each morning the birds would be waiting patiently for their breakfast. If for some reason whoever had housekeeping duty slept in, however, the ravens would fly to the roof of the cabin and peck away at the steel Yukon chimney until their morning meal was served.

Being scavengers, the birds would take their food from the easiest source possible. Often it was the dogs which ended up sharing their rations, although not on a voluntary basis. One raven would stand about an inch beyond the reach of a chained dog, flapping its wings and leaning over nose to nose with the harried animal, diverting its attention. Meanwhile, one or more others would zip in and relieve the dog of its dinner. The ravens took turns until each had had its fill.

The Simpson detachment had positioned three empty 45-gallon drums at the edge of their yard for burning garbage. The ravens would hop down inside the barrels to look for any table scraps which might be present, and drop whatever food they found upon the ground, sharing in the bounty equally. This activity resulted in a mess around the garbage area which had to be cleaned up on a daily basis. One day, Stan decided to try and scare the birds away. The shed which housed the light plant stood a mere 30 feet from the drums. Stan took a shotgun inside the shed and, opening the door just far enough to permit the gun barrel to get through, he attempted to draw a bead on the offenders. The ploy worked; as soon as the birds saw the gun they would fly off.

The only problem was that they would return just as quickly as they had left once Stan pulled the gun back inside the shed. Having much better things to do than to stand sentry over garbage barrels, the ingenious corporal devised a plan. He took an old broom handle and painted it black. His idea was to prop the broom handle

through an opening, keeping the birds at bay permanently. As he gave the invention a trial run, he was surprised to see that the birds paid absolutely no attention to it.

He tried the old method of opening the door and then poking the bogus shotgun outside, but the ravens continued on as though he wasn't even there. He tried again, but obtained no better a result. When he stuck the real gun barrel out the door, however, the ravens were gone in an instant. All Stan could do was laugh and shake his head in wonder at the intelligence of these ebony marvels of creation.

Of interest to all who occupied communities situated at the mouth of a river was the annual spring breakup of the ice. In the Mackenzie delta farther north, blockages of ice could cause flooding severe enough that some residents were forced to build platforms in the trees around their cabins, and to live on these platforms for three or four days until the waters once again receded. In the settlement of Arctic Red River, it was not uncommon for the water to rise over the 30 foot high riverbank.

The Mackenzie changes direction at Arctic Red, going from north and east to north and west. At breakup, the ice would pile itself on the far shore in sheets as large as an acre in size, and several feet in thickness, each plate climbing over top of another like dishes stacked for cleaning.

The force of the water pushing the ice out of the way was enormous. In the spring of 1948, Stan was taking the Officer Commanding of Aklavik Subdivision on the initial river patrol after ice out. When leaving the Aklavik channel, his practice was to drive the boat out into the main channel until adjacent a certain small island. At that point he could be sure that the water was not too shallow to navigate, and he would turn upriver. Cst. Byer failed to find the island, but believed he was far enough out to safely make the turn. When he and his party arrived at the cabin of Fred Cardinal, Stan asked the trapper about the landmark.

"I must be losing my mind," he said. "I was positive there was a little island out there."

"You're not crazy," the Indian informed him. "The ice took it out."

Stan was amazed; the island had been several acres in size, and it had been thick with many hundreds of spruce trees. And now it was simply gone.

Because the people knew the ice had to leave each spring, they were never surprised when it did, and they made the appropriate preparations. Rarely, if ever, was there either injury or loss of life attributable to breakup.

In Ft. Simpson crowds would gather to watch as the time drew nearer. The Liard River ice broke two weeks before that of the Mackenzie, owing to warmer spring waters flowing from British Columbia. It was quite a spectacle to see the mountain of ice being created across from their island community, as much as two thirds of which could be submerged by this time. Five foot thick blocks of ice inched their way up the riverbank towards the RCMP's facilities, which was itself some 35 feet above normal water levels. The ice would crash and groan with the sound of a thunderstorm as it was pushed headlong into and over the unyielding shorelines. Then, as the water pressure became simply too much for the ice to bear, it would push further down river in a sudden, explosive fury. The assembly cheered wildly, as though the event had been staged by Mother Nature purely for their entertainment alone. Then, as the flood waters abated, it became business as usual once more in the tiny community of Ft. Simpson.

The river provided Stan with a different sort of excitement in the early summer of 1955. The road from the island to the airport was still closed because of high water, and Jimmy Cree called one day to see if Stan could run him up with the police boat to pick up the mail. Jimmy's own boat had only a light duty engine, and he did not feel secure in attempting to navigate fast water in it. The trader apologized for the trouble, but he had been unable to find anyone else on short notice. The RCMP scow was a solidly built unit, manufactured by Charlie Hansen to his usual rigid standards, and was equipped with a 22-horsepower outboard. A short trip up the river would be an interesting diversion in an otherwise dull day, Stan figured, and he accommodated Jimmy's request without a second thought.

The trip to the airport was uneventful, and the two men loaded the boat with an unusually large number of mailbags. The weight was no problem for their rugged craft, and they began the run back to Simpson. As they exited the Liard to reenter the Mackenzie, however, a sudden wind blew up from the north. Within only minutes the water's surface transformed their peaceful run into a terror-filled roller coaster ride. The corporal had seen conditions far worse than these, but he had had the security of the St. Roch

under his feet at the time, and for a moment he believed his good luck had finally run out. With the boat sitting precariously atop the crest of a six foot wave, Stan cranked the kicker as hard as he could, and the scow spun a complete about face. Going with the waves gave him the opportunity to control the boat more readily, and he and Jimmy headed for the shelter of the Liard. The two of them were forced to overnight on shore until the wind died down, but they put the time to good use, laying out to dry whatever mail had been drenched by the water which had overflowed into their boat.

Earlier that same spring, the river did claim a victim. Just after ice-out, a noisy party was held along the Mackenzie's east bank.

"The first thing I remember about that incident," Stan recalls, "was this awful wailing. Everyone in town could hear it, and Art and I took the game warden's boat and went to see what was going on."

Art Trace also has a vivid memory of that evening.

"Tony Antoine, Moises' cousin, had fallen into the river, and their poor mother was just in hysterics. We looked up and down for a couple of hours and we couldn't find him. There was some suggestion that he had not really fallen, that maybe something else had happened and that Tony was thrown into the water, so we were pretty anxious to find the body." It wasn't until six weeks later that the corpse was discovered, however, by Art as he was returning from a boat trip to Ft. Wrigley.

"He was in an eddy, just sort of slowly turning around in the water."

Despite the amount of time which had elapsed, Tony was immediately recognizable.

"It was him, alright," Art told me. "His face was as clear as day." Normally a body which has been in the water for so long would be very difficult to identify, but the Mackenzie was still ice cold, and little decomposition had occurred.

"I had to assist at the autopsy," Art continued, "and it was confirmed that the cause of death was drowning, after all. Poor Tony just did a little too much partying that night. But talk about news traveling fast! When I got back to Simpson after finding the body, I tied up the boat and ran up to the office to get Stan, and by the time we got back down, everyone in town was standing around that dock. In just a few minutes the whole settlement had heard

that Tony had been found, and all the people ran down to see for themselves – every last one of them."

By mid-1955, the oil companies had expanded their role in and around Ft. Simpson, drilling exploratory wells along the Liard and the Mackenzie. The companies transported much of their supplies north by air, having little direct effect on Simpson's economy, although their practice of hiring local residents did provide an injection of much welcomed revenue. Stan and Art made the occasional trip to visit the camps, but little overall was added to their burden as a police force.

The following winter was to be Stan's last in Ft. Simpson, as his second three-year tour was drawing to a close. One evening Stan was called to take part in one of the regular shinny hockey games the Signal Corps arranged. These games were well attended by the local population and Stan, being somewhat of a weak skater, did not usually take part, as he was not particularly proud of his lack of skill. Many of the players, not the least of those among them the parish priest, were quite adept at the game, and the corporal was a little shy about putting his talents on display.

On this occasion, one of the two goalies could not make the game, and Stan was "volunteered" to take his place. He reluctantly agreed, although his puck stopping ability was limited to those shots which he could not sidestep before they hit him. Stan attributed much of the blame for his poor performance to the fact that his stick weighed in the order of 20 pounds, due to its having been patched several times with sheet tin and wire.

As the game wore on, the other players became less and less forgiving of his lack of experience, and the shots started to creep higher. Finally, one caught him in the Adam's apple, ending the game prematurely. Even worse, however, he was robbed of any opportunity to further voice his displeasure with the substandard equipment.

There was no skate sharpening machine in the community, so Stan purchased one, correctly realizing that his future in hockey was more in maintaining equipment than in playing the game. Those who fancied themselves as misplaced professional hockey players were grateful for the machine. Charging 35 cents a pair for his services, Stan spent three or four hours a night putting fresh edges on the blades of these frustrated NHLers.

When not engaged in this little commercial venture, Stan was kept occupied with another rebuilding project. Bill Day, Game Warden at the time, had picked up the remnants of a motor toboggan built by Bombardier, the company which would soon make the words "Ski-Doo" and "snowmobile" synonymous. Bill soon gave up hope of doing anything with the unit and sold it to Stan. With little more than a frame and a well-worn track to start with, he spent a few nights sketching and figuring out how he might make the thing work. He soon had a rough design, and mailed a request to his father in Brandon, Manitoba, for a crateful of items: an air-cooled, 10-horsepower Briggs and Stratton engine; an automatic belt-driven clutch; a roller chain; and a host of shafts, sprockets and pulleys. He fashioned a bed for the motor and transmission, and using reclaimed angle iron made up a track with cleats to grip the ice and snow. After much blue language and numerous cracked knuckles, the toboggan was ready for service. Stan used it to make runs to the airport and took it on the occasional 20-mile trip upriver.

A few days before Chistmas 1955, the detachment received a report from Bill Day that two pack dogs belonging to Pete McKeown were being neglected. Pete lived at the mouth of the North Nahanni River, and had a history of heart trouble. His neighbors feared that the man had become too ill to care for the animals, but none had seen him for several days, so their suspicions were unconfirmed. Art Trace and Moises Antoine traveled to McKeown's home by hired dog team to investigate. Cpl. Byer followed shortly in the RCMP's aircraft, CF-MPL, accompanied by five local trappers.

The eight men followed Pete's trapline and generally surveyed the area surrounding the man's home with no luck. Art's missing persons report notes that the home was left in a state which suggested that Pete was not intending to go very far; the buildings had not been locked, and there was water in the basin, kettle and pail inside the cabin. Cst. Trace concluded from this that the search for McKeown should be concentrated close to the dwelling. They found no sign of the man, however, and after a six day search, it was decided to return in the spring once the snow had melted. Sadly, although Bill Day had left the dogs plenty of meat, Art found them in terrible condition when he arrived, and he had no option but to put the animals out of their misery before making the trip

back to Simpson with McKeown's personal effects and papers, which included his last will and testament.

Cst. Trace returned to Pete's cabin a few months later and, as he had suspected, found the remains only a few hundred yards away. Identification wasn't an easy thing, however, as there was not much left of the man. Parts of his upper and lower jaws and a few scraps of torn clothing were all that had not been taken by scavenging animals and ravens.

"One thing every one knew about Pete," Art remembers, "was that he had all his teeth, and they were in perfect shape – no fillings. Really all I could locate of the body was a few parts of his jaw, and all the teeth were there. Most of his skull had been crushed by wolves chewing on it. I had seen Pete about a week before Bill reported him missing, and I'd left a tobacco can he had taken a shine to. He wanted it to keep his matches in. The tin was lying near the bones, so I was pretty certain it was Pete I'd found."

There was no physical evidence by which to precisely determine what had led to McKeown's death, but his medical history pointed to a probable cause.

Art had flown to the site this second time with Dr. Trone Nyhus in the doctor's own floatplane. A flurry of bartering had taken place before making the journey; Art needed a ride, Shell Oil had left a cache of helicopter fuel near the trapper's cabin along the riverbank, and Nyhus needed avgas. There was a definite risk that the cache would be swept from the riverbank if the waters rose, and Shell agreed to exchange a few kegs for the courtesy of moving the balance uphill and out of danger. At the end of the day, everyone was happy – except for Art.

"It was me who had to move the damn gas!" he recalls, somewhat less than fondly. "That bank was pretty much straight up, and a 10-gallon keg of gas weighs about 75 pounds. I'd wrestle one up on my back behind my head and make the climb. Man, was I tired after 20 or so of those damn gas drums."

Shell Oil had brought in the bubble-nosed Bell helicopter in the fall of 1955, and used it to ferry men and supplies to the company's seismic camps. It was the first helicopter Stan had ever seen and, as was his habit, he managed to wangle a complimentary flight out of the pilot, Don Jaques. Don even suggested that Stan's young son should accompany them.

Not satisfied to merely enjoy the experience, Stan took the opportunity to survey the area over which they flew. North of the settlement, he noticed a pair of home brew pots cooking in the middle of a field, left temporarily unattended. Taking note of their location, he later returned to dump the pots. He made little effort to determine who had rigged up the still – justice had been served.

By late spring of 1956, Jean and Stan had most of their furniture and other belongings packed away for their impending departure. These goods would travel south by barge once word of their destination was received. The RCMP's Air Division had a heavy schedule planned for that season, and it was decided to effect transfers first before other requirements were taken on. Having an excellent spring-conditions airport, Ft. Simpson was among the first of the Force's detachments to be notified of a change of men. In late May, the Signal Corps received a wireless message that Stan and his family were to fly out the next day. The couple was busily gathering the rest of their possessions for the flight when they were whisked away to a hastily arranged going-away party. A baby-sitter had been arranged for Doug, and a royal sendoff was hosted by the Signal Corps for both Stan and Jean, and for one of their own as well. Andy Ackerman and his wife, Jean, and their family had just received news of their transfer.

By three in the morning, the Byers decided to get a few hours of sleep before finishing the chore of packing. The party had taken something of a toll on the poor couple, however, and when Stan was awakened by Art at ten o'clock, the plane was already at the airport and waiting to leave again. Art had been kind enough to pack the rest of their things into trunks and suitcases, and he hustled the ailing corporal and his family into the Jeep for the 10 mile ride. Stan climbed aboard the plane, having but a 30 second introduction to the man who would replace him before doing so. There was little opportunity for extended good-byes before they were escorted to their places on the twin engine Beech 18. The door closed, and Stan took a last look at the place which had been home for a half dozen years.

For no apparent reason, the plane's pilot, Benny Ruhl, walked back into the passenger cabin and stopped next to Stan.

"Are you sure you remembered everything?" he asked.

"I think so," Stan replied, still a little foggy after the previous night's shenanigans.

Benny pointed out the window.

"What about the little guy?" he asked, a smile growing on his face. Out on the tarmac stood Douglas, crying miserably at the prospect of being abandoned at the tender age of three years and 10 months. The youngster was quickly reunited with his forgetful parents, and the plane's engines roared to life for the flight to Edmonton. Whether it was to be his penance or simply the result of a poisoned system, Stan would never be sure, but that flight was the worst he ever suffered through, before or since. Arriving in Alberta's capital city, Stan was thankful that no one from the Edmonton detachment came out to meet them. Wearing a two-day growth of beard and desperate for a change of clothes, Stan hailed a taxi for himself and family.

After a day's rest and recuperation at the home of Jean's sister, Dot, he had time to reflect on his years spent in Canada's North. It was an experience which he would never forget, nor would he ever wish to. He had fallen hopelessly in love with everything about the North, and whether he knew it then or not, he would one day return to the place where, more than any other, he felt truly at home.

PRINTED AND BOUND
IN BOUCHERVILLE, QUÉBEC, CANADA
BY MARC VEILLEUX IMPRIMEUR INC.
IN JULY, 1997